FORCE THROUGH DELICACY

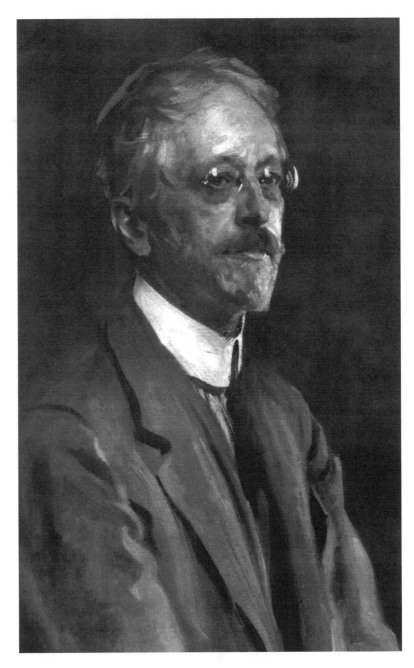

Portrait of Charles H. Woodbury, NA, was painted by John Singer Sargent in his studio in 1921. In the 1960s David and Ruth Woodbury donated the portrait to the National Portrait Gallery, and they have kindly given permission for this reprint.

FORCE THROUGH DELICACY

The Life and Art of
Charles H. Woodbury, N.A.
(1864-1940)

GEORGE M. YOUNG

With an Introduction by
RUTH R. WOODBURY

PETER E. RANDALL PUBLISHER
PORTSMOUTH, NEW HAMPSHIRE
1998

ACKNOWLEDGMENTS

We wish to thank the people who have helped in the production of this book, especially Timothy Decker of the Berkshire Museum, and Mary Leen, Kara Schneiderman, and Michael Yeats of the M.I.T. Museum Collections for help in assembling photos, Bill and Terry Vose of Vose Galleries, Silas Weeks of the Dover Friends Meeting, and Ronald Latham of the Berkshire Athenaeum for permission to print photos of works in their collections, and Peter Woodbury, Doris Troy, Warren Seamans, and Donald Krier for assistance, suggestions, kind comments, and encouragement. Very special thanks are due to India Woodbury and Donald Jones for initiating this project and supporting it to a successful completion.

George M. Young

ND
237

.W8
Y68
1998

Printed in the United States of America
Design: Tom Allen

Peter E. Randall Publisher
Box 4726
Portsmouth, NH 03842

Distributed by University Press of New England
Hanover and London

Library of Congress Cataloging-in Publication Data

Young, George M.
 "Force through delicacy" : the life and art of Charles H. Woodbury, N.A. (1864-1940) / George M. Young ; with an introduction by Ruth R. Woodbury.
 p. cm.
 Includes bibliographical references.
 ISBN 0914339-66-4
 1.Woodbury, Charles H. (Charles Herbert) , 1864-1940.
 2. Painters--United States--Biography. I. Woodbury, Charles H. (Charles Herbert) , 1864-1940. II. Title.
ND237.W8Y68 1998
759.13--dc21
[B] 98-22685
 CIP

CONTENTS

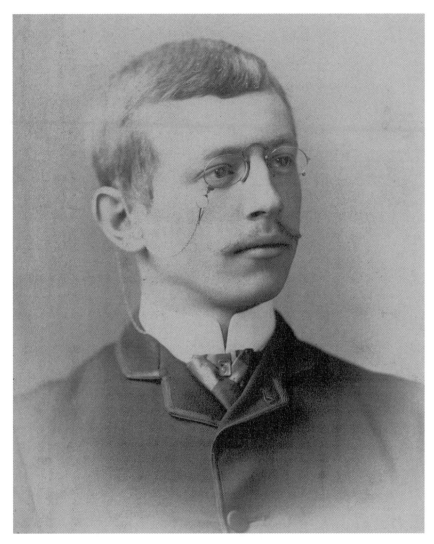

Charles H. Woodbury as a young man. Collection of Ruth R. Woodbury.

FOREWORD

"When an irresistible force meets up with an immovable object, what do you have?" "Spray," said the man as he clapped his hands in an upward motion thinking of the huge storm waves crashing on the rocky coast of Maine.

So here we have Charles Herbert Woodbury speaking to his first class in the art of painting in June 1898 in his studio in Ogunquit, Maine. This, of course, was not his first class in painting, but first only in his Ogunquit studio.

He had already put himself through a mechanical engineering degree with honors at M.I.T. by giving art classes and private lessons around Lynn and Boston.

We are celebrating the 100th nniversary of the occasion of his first Ogunquit class by publishing this fine biography of Woodbury by George Young, distinguished author, proficient in many languages, and an enthusiastic auctioneer of paintings, etchings, and drawings. I, Woodbury's daughter-in-law, have the honor of writing the introduction.

I have many fond memories of this industrious individual. In the evenings when it was too dark outdoors to paint, after a light supper, Woodbury would sit under a lamp at the round mahogany table in the living room and look over his extensive stamp collection.

I remember him pushing his glasses with their thick lenses and their gold frames up over his head and holding the stamp right close to his eyeball to determine its value and authenticity.

In 1934 my husband David and I took one of his summer classes in Ogunquit. It lasted for two weeks, going every day but Sunday, from 9:30 a.m. to whenever you finished your assignment for the day. Each morning he would lay out the plan. He would say, "Now I want you to go out on the rocks around the studio and pick out your favorite view, squeeze out onto your palette the colors you will need to paint the view, then paint it like you'd been sent for!" Another day he would say, "Today pick your favorite view again and paint it in the morning, come back in the afternoon and paint it again on a different pochadé (8 x 10 canvas-covered board), and then paint it again once more in the early evening. This will show you, when comparing the three pochadés, how important the changing light is and how accurately you have recorded it."

Saturday we would put up our work for the week on racks made for the purpose by his father Seth Herbert Woodbury, an accomplished cabinet maker. Charles would then give his critique of our work with humor and enough challenge to make us do better next time. We would all enjoy the critiques, and although sometimes there were tears, they would quickly clear up because of his friendly manner.

Seth Herbert was as industrious as he was skillful. He made the best box for your painting work that you could want, of nicely finished wood, probably poplar. When you opened it, it behaved like an easel, holding your pochadé in the top half in grooves made for the purpose. The bottom half held your tubes of paint in little grooves to keep them and the brushes separate , and last but not least your palette kept the tubes in place when the box was closed. Two good hooks-and-eyes kept it closed and there was a handle for carrying it easily. You would carry this complete equipment, bring along a paint rag if you wished, set it upon the rocks or anywhere and get right to work.

Mrs. Ireland had a gift shop in Perkins Cove called The Brush and Needle. Barnacle Billy's is now in its place. For the convenience of the Woodbury students she had a place called the Artists Corner where they could buy paints, palettes, brushes, and pochadés, and one or two paint boxes made by Seth, although he rather liked to sell them himself.

Mr. Woodbury was an expert at having you teach yourself by observation and encouragement. He taught many who were already artists, and many who had never touched a paintbrush. He kept you alert by his comments. You never knew how he would make you realize you had not done it right.

My mother, Beatrice Baxter Ruyl, already an artist, enjoyed the summer course even before I met my future husband, Woodbury's son David.

One lovely memory is of a story told to me by David, an incident long repeated in his family and written up in "Yankee with a Paint Brush," published in the *New England Galaxy* in 1964.

One afternoon in October the family was riding out in one of Joel's carriages when four-year-old David yelled out in his childish voice, "Oh, see the blue horse!" Now quoting from the article, "My parents came alive at that point." They realized that a white horse standing in a shadow does look blue. This is exactly what they had been trying to teach their students to realize and carry out in their painting.

Another vivid memory concerns the "Dynamite story."

The studio was being built about 1900 on a ledge overlooking

Perkins Cove. In those days you had to drill the holes by hand for the sticks of dynamite. If the sticks were too large for the holes, you shaved them down with your pocketknife. They found that the shavings tasted better than "tobaccie." Davey wanted some too.

Soon his mother, who had been busy painting, heard about it and came storming out of the studio and scraped the shavings out of his mouth with her finger — making a choice remark or two to the men. "Dy-mite," repeated the four-year-old, and he never ceased annoying his mother with the story.

We knew in our family that Woodbury and John Singer Sargent had studios in Boston and painted each other in 1921.

Later in the 1960s, Mr. Robert Vose Sr., came to Ogunquit, probably to see if he could buy some Woodbury paintings. He sat on the sofa in our living room and looked toward the fireplace with its cheerful blaze. He recognized at once the portrait of Woodbury by Sargent.

"Oh!" he said, "that should be in the National Portrait Gallery in Washington, and I will see that it gets there."

So it is that Michael Culver, Curator of the Ogunquit Museum of American Art, has permission to display it in the June 1998 Woodbury exhibition to celebrate the 100th anniversary of Woodbury's first art class in his studio in Ogunquit.

We wish the two portraits could be shown together, but the Sargent memorabilia doesn't seem to know of the Woodbury portrait.

The MIT Museum, formerly directed by Warren Seamans, at 265 Massachusetts Avenue, Cambridge, has added glamour to the already prestigious Massachusetts Institute of Technology and is something wonderful to see.

And the exhibit of Woodbury's work is the very best of the lot. One in the group is called "Panels of the Sea" and it takes up thirty feet of wall space!

The book *Earth, Sea, and Sky*, which Warren calls a catalogue of the exhibit, is full of color and black-and-white reproductions of some of Woodbury's pictures. Included also are appreciations of Woodbury's work by many knowledgeable people, comments which represent a full course in Woodbury's talents and abilities.

I want to thank the Vose Galleries for the wonderful chronology of the Woodbury events in its catalog of September 1979.

Now, I must conclude these lovely memories and let you get on to George's charming and erudite biography.

Ruth R. Woodbury,
January 1, 1998

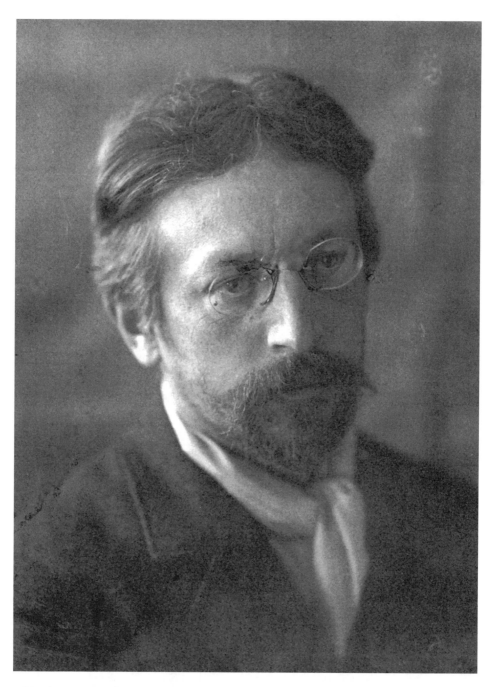

Charles H. Woodbury, c. 1910. Collection of Ruth R. Woodbury.

I

'This Rising Young Painter'

In February of 1882, the family story goes,[1] Winslow Homer, the great American painter of the sea, presided at the twenty-fifth annual juried show of the Boston Art Club, a major venue for the exhibition of work by New England's leading professional artists. As one of the winners, the painter of a work titled *Sketch of Fish Houses, Swampscott, Massachusetts,* came forward to receive his award, Mr. Homer beamed delightedly and exclaimed: "Why, you're nothing but a boy!"

And indeed, in 1882, the recipient, Charles Herbert Woodbury, was only seventeen years old, a high schooler from the nearby town of Lynn. At the moment, no one could possibly have foreseen how fitting it was that this particular forty-five-year-old master was presenting an award to this particular seventeen-year-old novice. For in February 1882, Homer, briefly back in America between extended stays in England, had not yet settled in Prout's Neck, Maine, and had not yet begun the masterful studies of wave, wind, and rock that would define sea painting in American art. And Woodbury had not yet even seen, much less painted, the Ogunquit shore views that would later earn him the reputation as Homer's heir, the foremost of his generation at painting the interaction of elemental forces where land meets sea. And though at this moment neither was Homer ready to pass a torch nor was Woodbury ready to receive one, the recognition by a leading artist at an important professional exhibition provided just the encouragement that Woodbury needed to set his sights on a career in art.

As Charles Woodbury's son David later wrote: "It was this incident, as much as anything, that convinced young Woodbury that he could and should become a painter." [2] For although he began to show artistic talent at a young age, teaching himself to draw at five and painting in colors from age ten, Woodbury did not receive early encouragement from his family for a career in art. His father, Seth Herbert Woodbury (1841-1916), who could construct just about any-

1

thing with his hands, had once hoped to make a living as an inventor. Finding that all his best ideas had either already been discovered or were unmarketable, however, he struggled to provide a living for the family as a furniture builder and cabinetmaker. As one whose own ambitions had been disappointed, he did not want to encourage his son's hopes for a career in which success was extremely rare, security almost unattainable, and frustration, failure, and lifelong deprivation the likeliest outcome. Though he must have been proud not only of his son's artistic talent but also of the character traits evident in the determination and self-discipline the boy showed in his artistic endeavors, Seth Woodbury wanted to provide Charles with an education toward a practical career and a promise of occupational stability that a life in art was unlikely to offer.

Inventiveness, mechanical ingenuity, and skill with hand tools seem to have been family legacies, going back through several generations of Woodburys. But despite his inherited skills, Seth Woodbury had never had the basic technical training that would have permitted him to make full use of his building talents. And like his father and other Woodburys before him, Charles also demonstrated an early aptitude for mechanical construction. At age twelve he walked repeatedly half a mile back and forth between his house and the Lynn railroad station to draw and build, in wood, a perfect, elaborate scale model of one of the fancy locomotives of the day. So after high school it was decided that Charles would not sail off to study art at the academies in Paris and Florence, as most of his comparably gifted contemporaries would do, but would go just down the road to M.I.T. to obtain the solid background in engineering that Seth Woodbury had missed.

In the fall of 1882, a little more than half a year after being presented an award at the Boston Art Club by Winslow Homer, Charles Herbert Woodbury, future painter of earth, sea, and sky, entered as a freshman what was regarded even then as the toughest engineering school in the country. As the artist's son later wrote about the M.I.T. of that day: "No less than three-fourths of the students entering had failed to graduate. It was such mind-twisting work that the Boston papers carried editorials condemning the 'abuses' the professors were supposed to visit on their overworked classes. One paper even suggested that some boys had ended up as suicides. This was like a red flag to my father, a challenge he couldn't ignore. He resolved to battle his way through *and* to paint at the same time."[3]

During his four years at M.I.T. Woodbury took the full program of

courses, "mind-twisting" and otherwise, that included several levels of algebra, geometry, trigonometry, and calculus, chemistry, physics, thermodynamics, steam engineering, general statics, descriptive astronomy, kinematics and dynamics, strength of materials, hydraulic engineering, metallurgy, theory of elasticity, mechanical drawing, mechanism of shop machinery, carpentry, construction of gear teeth, slide valve, link motion, foundry work, blacksmithing, chipping and filing, engine lathe work, construction and equipment of mills and machine shops, machine design, one year of French, two years of German, rhetoric, English composition, English literature, modern history, constitutional history, political economy, and military drill, in addition to writing a thesis, "Design of Builder Motion and Driving Mechanism of the Roving Frame"[4]—and this was not a time when one could rely on thin yellow paperbacks with titles like *Hydraulics for Dummies!*

Not because of the difficulty of the course work, but because of his growing abilities in another direction, Woodbury decided as early as his sophomore year that he would follow his artistic calling rather than pursue a career in engineering. Since he was already making money in art, he could easily have dropped out of engineering school, but he did not want to feel a quitter. So despite knowing that he would probably never make professional use of his specialized training, he completed the entire rigorous program. In 1886, he received his S.B. degree, with honors, in mechanical engineering. The completion of an engineering degree not only demonstrated Woodbury's strength of character, a determination to prove himself able to master a very difficult subject, but also provided a thorough conceptual acquaintance with all that was then known of the physical world, a scientific understanding of force and motion, and a respect for the "thing in itself" as much as for the idea of a thing. As modern art would later shift its focus more and more from the representation of objects themselves toward the representation of our ideas, perceptions, impressions, and aesthetic manipulations of those objects, Woodbury would maintain his engineer's respect for the item itself. He never lacked imagination and was never in danger of being labeled a literalist, but throughout his life the focus of his art would remain on the forces and objects he was transforming into art rather than on the fact that he was transforming them.

One of the marks of Woodbury's uniqueness is his double vision of both aesthetic and physical models of reality. He somehow manages to give full expression to both and creates a world that works as both

artistic vision and rigorously accurate observation. Woodbury apparently never regretted his engineering education, and part of his strength as an artist is due to the observant, practical, analytical cast of mind that led him to M.I.T. and to the body of knowledge and sharpened intellectual habits that he acquired there. Among artists of his generation he stands alone in his ability to unify artistic and scientific modes of perception.

At age five he began his lifelong habit of sketching everything that caught his attention. A sketchbook from 1871 contains a wonderful drawing of a dog, so expressively rendered that we know at once , more than a century later, that this is not just a dog but a good dog, friendly and warm, loving and loved. It looks at us from a patch of deep grass, eyes alert, tongue hanging out, its shaggy head waiting to be patted.[5] Woodbury loved dogs, he always had one or two around the house and made hundreds of sketches over his lifetime of his dogs sleeping, scratching, sniffing, and going about the important business of their doggy lives. In his later sketches sometimes just one elaborately curved line would be enough to tell us that this was Boy the bull terrier, curled up at rest.

Another published drawing from the same sketchbook shows a farrier shoeing a mare, as a foal and a dog look on. Although the perspective is slightly awkward and the horses' eyes are probably a bit too large and too round, the drawing is good and hints at qualities that will characterize the mature artist's work. For one thing, every beast and person in the drawing is doing something different: The farrier holds the hoof and concentrates on getting the nails lined up correctly; the mare stands patiently, enduring the operation with calm forbearance; the dog is half seated, leaning out, his tongue extended, keeping a close eye on the proceedings; the foal is cautiously watching both the dog and the farrier from a safe position behind the mare. It is all a bit cluttered, stiff, and awkward, still a child's drawing, not a master's, but already evident is the instinct that Woodbury would later formulate in his famous dictum: "Paint in verbs, not in nouns."[6] The drawing, though by only a six-year-old, is not about a group of static figures but about what the figures are doing, each by himself and all in concert. Young Charles at this age may not have known a noun from a verb in grammatical terms, but already in drawing he could depict the difference.

His family must have both admired his talent and feared where it might lead him. But in the Lynn of that day a boy hoping to become a professional artist did not have to look far outside the family for mod-

els and encouragement. Close enough to Boston to benefit from the cultural emanations, yet distant and small enough to have developed its own sense of community identity, Lynn was, if not a hotbed, at least a very supportive environment for a budding artist. In the 1870s and early 1880s the leading painters in town were Edward E. Burrill (1835-1913), Charles Edwin Lewis Green (1844-1915), and Edward A. Page (1850-1928), each of whom had already attained, or soon would attain, a respected and durable position as an artist of regional—perhaps even national—importance. Although they painted a variety of subjects, all three shared a special fondness for North Shore coastal scenes with stretches of tan sand, some beach houses, perhaps a beached fishing boat with a few figures surrounding it, maybe a distant sail or two. Often with low, flat horizons and rich, deep greens, their paintings resemble the Dutch coastal and canal scenes of their Hague School contemporaries and immediate predecessors.

Burrill, the oldest of the three, and probably the one most highly regarded in Lynn at the time, was a professional artist, arts promoter, and teacher who excelled at crayon portraits of local citizens, rustic genre scenes, Barbizon-style landscapes with cattle, and shoreline views. Works such as *Old Folks by the Fire* (Young Fine Arts Auctions, April 1994) and *Waiting for their Feeding Time* (Skinner, September 29, 1988) still turn up in the New England art market.

C.E.L. Green was a businessman and town official in Lynn who by about 1880 had attained sufficient artistic confidence and financial security to devote the rest of his life to painting. In 1889 he traveled to Europe, associating himself with the Newlyn School in Cornwall, and on returning to New England exhibited regularly at the Massachusetts Charitable Mechanic Association and at least once at the Boston Museum of Fine Arts. His paintings not only of Lynn but also of North Africa, Newlyn, and the New England countryside still turn up today in New England art galleries and auctions, but not frequently enough to satisfy the many avid collectors of his works. [7]

E.A. Page, the third of the important Lynn painters in the generation before Woodbury, was best known for his North Shore scenes with haystacks in the salt marsh, or boats and beach houses on the strand, but he also painted still life and genre pictures such as *Sitting by the Fire.* (Young Fine Arts Auctions, July 12, 1997). Sophisticated, high-quality works by these and other local artists were frequently on display in several Lynn galleries and shop windows, and the local daily and weekly North Shore newspapers of the late nineteenth century

devoted not only much more attention, but also attention better written and of higher intellectual quality, whether supportive or critical, to all the arts—music, theater, and poetry, as well as painting—than is usual in the papers of our day. So for an aspiring young artist like Woodbury, to have grown up in a small town like Lynn of the 1870s and 1880s was in no way a deprivation.

The first work by Woodbury to receive local recognition was an 1877 school drawing, a life-size chalk-and-crayon copy of Landseer's *Monarch of the Glen*. School authorities were apparently so impressed with the quality of the draftsmanship that they had the blackboard covered with glass to preserve the drawing for future art classes. But Woodbury's first public exposure outside school was in the Lynn Art Exhibition of 1880, where his oil of a sunset in Lynn harbor, with a lumber schooner in the foreground and Lamper's wharf in the distance, won second prize in the amateur division. First prizes in the professional division for all three categories, oil, watercolor, and crayon, went to Burrill. Other artists in the exhibition whose names are still familiar to collectors of nineteenth-century New England regional paintings were the marine artist T. Clark Oliver (1827-1893), the landscape painter Nathaniel L. Berry (1859- ?), and the above-mentioned C.E.L. Green.

As Sinclair Hitchings has noted,[8] the young Woodbury, like most beginning artists of the day, was much taken with the idea of the picturesque. Such books as *American Scenery* (1838), with illustrations by William H. Bartlett, *Picturesque America* (1872), illustrated by Harry Fenn, and William Oakes's *Scenery of the White Mountains* (1848), illustrated by Isaac Sprague and G.N. Frankenstein, offered vivid renderings of spectacular but nearby encounters in the international quest for everything picturesque. So in August 1881, Woodbury and a friend made a brief sketching trip to Wolfeboro, New Hampshire, where Woodbury recorded his versions of *Woodland Cascade, The Wooded Path, The Old Mill, and The Tower by Moonlight.* These drawings, along with sketches made on other day trips to the nearby shore towns of Salem, Marblehead, Swampscott, Gloucester, and Newburyport, were exhibited with those of another "boy artist," Eddie Stewart, in the winter of 1881-82 at Barton's Gallery on Market Street in Lynn. A reviewer for the Lynn newspaper wrote: "It is an ambitious attempt, but whoever examines the sketches will say that there is no little merit displayed and that the youthful artists are deserving of praise." Of Woodbury's contributions, the reviewer writes: "Master Woodbury seems to us to be making rapid strides in art, and some of the sketches which he shows at

Barton's prove that he has not been idle of late. 'Woodland Cascade' is a beauty, one of the best he has ever done. . . . The above sketches are also for sale, and we hope Master Woodbury will receive such encouragement as will induce him to persevere in the path he is following."[9]

Woodbury's pictures sold well from the start. The 1880 Lynn Art Exhibition prize-winner, *Sunset, Lynn Harbor,* had sold on the third day of the exhibition for $15. Soon after, he sold to Mrs. John A. Andrew a painting of a basket on the beach for $25. From then on he never had great difficulty exhibiting and selling his new work. In 1886, for example, the leading New England art publisher, L. Prang, issued a set of lithographic reproductions of the twenty-one-year-old artist's drawings entitled *Six Pencil Drawings by Charles H. Woodbury*—a considerable honor for such a young artist. And in the following year, 1887, he exhibited thirty pictures and sold all of them in his first Boston solo show. Much later, he would puzzle an Ogunquit farmer by selling a painting of a cow for considerably more money than the cow was worth, and would sell a single painting of the Ogunquit seashore for more than the seaside land itself had cost him. Seth Woodbury's fears of inevitable financial ruin if his son pursued a career in art proved groundless.

Judging from the similarity of his early North Shore paintings to the best work of C.E.L. Green and E.A. Page, it is clear that Woodbury learned a great deal from the older generation of Lynn artists. He also studied at M.I.T. with Ross Sterling Turner (1847-1915), an instructor in architecture and drawing whose richly tonal watercolors are still highly regarded by connoisseurs of American work in that medium. Woodbury credits Turner with kindling his interest in watercolor as a medium, and with helping him reach the decision to undertake a career in art.[10] But for the most part, Woodbury taught himself to draw and paint and arrived at his mature ideas of artistic technique not from studying with older masters but by teaching younger, less experienced artists.

Woodbury began his lifelong career as an art instructor while still a student at M.I.T. His first pupil was George Blake, and as Woodbury wrote, "When I first taught at seventeen, I was expected to teach watercolor which I had never tried myself so I taught them to use oil until I learned all about the other medium."[11] On weekends he taught sketching classes in Swampscott and twice a week attended life drawing classes at the Boston Art Club, where in 1883 he was elected the prestigious club's youngest member—all this in addition to a full load of those "mind-twisting" courses at M.I.T.

At this time, Woodbury's paintings began to receive newspaper

attention beyond Lynn. Already in 1881, his entry at a show at the Mechanics' Fair had been mentioned in the *Boston Journal,* and now his entries in the Boston Art Club shows began to attract both positive and negative commentary in the fine arts columns in the various Boston papers. In commenting on what was probably the same painting of a Swampscott fishhouse that Winslow Homer had seen, the reviewer writes in 1882: "Young Woodbury has started with a fine style. His color is strong and rich, particularly the purple and dark gray tones so effectively seen on this canvas. The artist calls his work a sketch; we should be willing to accept it as a complete picture." In reviewing an exhibition at Chase's Gallery, another reviewer comments: "Landscapes both in oil and watercolors predominate, of which one of the most interesting is Mr. C.H. Woodbury's view on the shore of a river, which is a strongly painted and able work. In respect of breadth and tone it is one of the most successful pictures that this rising young painter has yet produced"[12] Other artists whose paintings appeared in these exhibitions, and against whom Woodbury's work was being compared, include J. Francis Murphy (1853-1921), Scott Leighton (1849-1898), Hendricks A. Hallett (1847-1921), Charles Melville Dewey (1841-1937), Thomas Wilmer Dewing (1851-1938), Franklin Whiting Rogers (1854-?), Charles H. Turner (1848-1908), Alfred Ordway (1819-1897), Samuel W. Griggs (1827-1898), and Samuel Lancaster Gerry (1813-1891), all of whom were at least a decade older than Woodbury, and all of whom produced work that is still highly regarded by collectors and scholars of the period.

In the midst of such excellent company, the twenty-year-old Woodbury received first prize at the Boston Art Club exhibition of 1885 for *On the Marsh,* considered by the reviewer "the best Mr. Woodbury has yet produced." The club bought this painting for $150.

But it was not always blue ribbons and lucrative sales for Woodbury. Occasionally the press of the day was less than flattering : "A second look at Woodbury's 'Low Tide' does not improve my opinion of it," one reviewer wrote. "He has made too free use of the palette knife, shoveled the paint on in fact, and parts of it were done in too much of a hurry. It is well composed and has good points about it, but is tricky and deceiving . . . No. 154, 'Gloucester Mist,' by the same artist, is poor and unpleasant, lacks composition and, hanging as it does directly below 'Low Tide' shows the other end of the scale."

And a year later, at another Boston Art Club show, a writer grumbles: "It is depressing to see, pushing the leaders in this exciting contest, some men whose past achievements have raised the expectation of bet-

ter things—among them Messrs. Wagner, Woodbury, and Paskell." And between dismissing the works of Jacob Wagner (1852-1898) and William Paskell (1866-1951), the writer complains: "Mr. Woodbury heretofore has painted some of the most hopeful pictures ever sent out by a young artist, and many persons will remember the beautiful charcoal drawings and bits of quiet color that he showed in the exhibitions of '82 and '83. Since then he has steadily retrograded, until nothing can save him but a sharp pull-up and a settling down to serious hard work."[13]

Serious hard work was the last thing anyone needed to advise Woodbury to settle down to. What this particular reviewer seems to have objected to is Woodbury's turn away from the elaborately detailed romantic and picturesque woodland scenes toward the simpler but more painterly shore views that combine areas of strong color with those of nearly bare canvas. Another reviewer, writing of the same pictures, understood and appreciated Woodbury's development: "For easy and supreme rendering of a given effect, the two landscapes purchased by the club—one by Charles H. Woodbury, the other by John R. Stites —are probably unique in the record of recent art. As rapid and unlabored art, that is; for there are a number of American painters who can render as closely natural effects as these two men. But as examples of nonchalant dash and confident carelessness —justifiable, as it seems—as pieces of refreshing vigor and verve,as manifesting quick, keen sight and conscious power of accurate rendering, the two pictures surely deserve the honor they have received. . . .'On the Marsh' succeeds first because of its truthfulness of effect, its free and rapid handling." And here the reviewer points to qualities that will continue to characterize Woodbury's best work for the rest of his life: "Perspective, air, distance, color, rendering of the nature of different earths and sands; these are some of its separate distinctive qualities, and together they make up the sum of extreme excellence which is so marked. It is life that makes the picture—the life in the high luminous clouds, the distant air full of bright sunlight, the sliding and dropping bank of fat black marsh clay, the disagreeable black water. It only needs for one to have seen the identical bit of marsh to realize to the full how wonderfully the painter has caught its actual nature."[14]

For the next fifty or more years, commentary on Woodbury's art emphasized these same qualities: air, color, distance, perspective, the combination of realistic subject matter and painterly technique, the deceptively unlabored appearance, the "nonchalant dash and confident carelessness," all achieved, of course, only through long, painstaking effort.

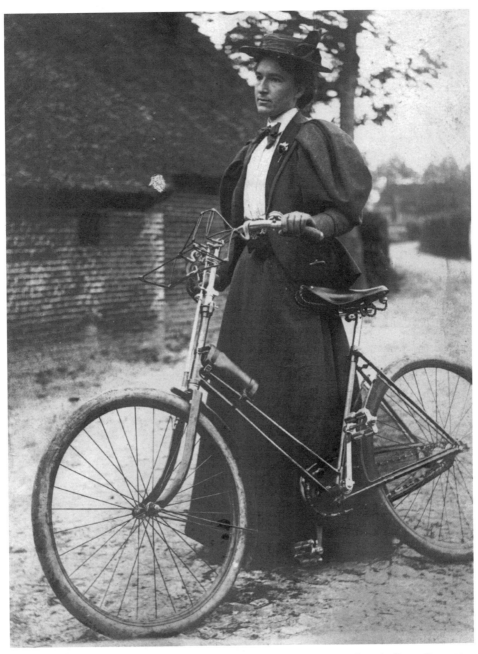

A Berwick Academy graduate and a friend of the writer Sarah Orne Jewett, Marcia Oakes Woodbury had a fine gift for portraiture. Her paintings of simple Dutch country folk, especially children, were so highly regarded in her brief lifetime that they sometimes won higher prizes than her husband's in their joint exhibitions. Collection of Ruth R. Woodbury.

II

'I Can't Teach You To Paint, But I Will Marry You If You Let Me'

In addition to his art and his engineering studies, a stable family life was important to Woodbury. Both his father, Seth Herbert Woodbury, and his mother, Mary Parker Woodbury (1841-1937), were of old Massachusetts colonial stock. The first North American Woodbury, a civil engineer, came to Massachusetts from England in 1628, laid out the town of Salem, and is said to have been mentioned in one of Hawthorne's romances.[1] Like Charles's father, other earlier Woodbury men were inventors, having received patents for such devices as a submarine gun, a dummy engine, and an important component of a planing machine. The family of Woodbury's mother, the Parkers, came from Cape Cod to Essex County some generations before.

Though not extravagantly wealthy, the Woodburys were a prosperous, prominent family in Lynn. Woodbury's grandfather, Seth D. Woodbury, had been a leading businessman in Lynn from the 1840s though the end of the Civil War. The furniture store, which had provided substantial goods to most of the households in Lynn, was—complete with wings and platforms and decks and balconies—the most ornate : in the words of one newspaper article, "the most pretentious store of its kind that had been established in Lynn."[2] Woodbury's father was more interested in making furniture than in selling it, but even though he was not able to prosper from his inventions, he did hold several patents and attained at least some local fame for the Woodbury Loom, a device that facilitated the transformation of rags, raffia, yarn, and cotton into rugs, afghans, sofa pillows, and the like. According to an educator quoted in a newspaper clipping, the Woodbury Loom was declared to be "the best in the market," and Mary Parker Woodbury, the artist's mother, was an expert at weaving rugs and other articles on it.[3] Photographs of the Woodbury house on Oxford Street in Lynn show a substantial, handsome, white frame residence with picket fences and

The house on Oxford Street, Lynn, where Woodbury was born. Collection of Ruth R. Woodbury.

pleasant lawn gardens on a main tree-lined street. The Woodburys, it is clear, were not bohemians. The artist came from generations of talented but practical people, (Charles had a brother, Fred, who died at the age of twelve, "already a violinist with the proportions of genius") good citizens, prominent contributors to the community's prosperity and welfare. And when it was Woodbury's time to start his own family, it is no surprise that he chose to marry a person like Susan Marcia (Susy) Oakes (1865-1913), a gifted young artist who was the daughter of a judge from South Berwick, Maine.

The Oakes family lived in a large, square white house on Academy Street in South Berwick, similar in prominence and comfort to the Woodbury home in Lynn. Abner Oakes was Probate Judge of York County, but Susy's mother, known to everyone in town as Missoakes, was the one who "ruled the neighborhood, and ran her own home in the grimly competent do-for-yourself tradition."[4] The youngest of nine children, Susy attended school just up the street at Berwick Academy,

the first private school and still one of the finest in Maine. After graduation, perhaps following the lead of her older friend, neighbor, and fellow Berwick alumna the writer Sarah Orne Jewett (1849-1909), she decided that instead of waiting for a suitable local bachelor to enter her life, she would seek an independent career as an artist.

With the reluctant consent of her parents Susy moved to Boston to live with a married sister, and there she enrolled in art classes taught by the Italian master Tommaso Juglaris (1845-?). Unfortunately, after winning the battle for independence against the formidable opposition of Missoakes, Susy confessed to her sister that she was not learning a thing from the volatile Juglaris. She had, however, met a very talented young engineering student who also attended her art class, and when that young man—Charles Woodbury—opened his own studio and began accepting pupils after graduation from M.I.T. in 1886, Susy Oakes followed him.

But even Woodbury, today widely recognized as one of the most able and effective American art teachers of the century, had no luck teaching Susy Oakes. After months of frustration, as their son later wrote: "One day he drew her aside, and taking great pains to achieve a tone of solicitude, regret, yet respect, he said to her, 'Miss Oakes, I don't know how to tell you this without offending you, but I guess I have no right to take your money any longer. I simply can't teach you to paint.' As the family legend has it, they stood looking at each other for a considerable time, Susy apparently enjoying his discomfiture and having no intention of helping him out. Charlie took a deep breath and blurted, 'I can't teach you to paint but I *will* marry you if you'll let me.'"[5]

He asked if he could call her Marcia, which he thought suited her better than Susy, so from their June 1890 marriage forward she lived and painted as Marcia Oakes Woodbury. As Roberta Zonghi observes in her fine essay on Woodbury as a teacher, it was certainly not lack of artistic talent on Marcia's part or a lack of teaching ability on Woodbury's that prevented successful instruction; rather, "it seems that perhaps Mr. Woodbury was not focusing his scientific mind on teaching when it came to Miss Oakes."[6] Their marriage was a happy one, fully an artistic as well as a domestic partnership.

In August 1890 they sailed for Europe, where Marcia's talent for figure painting began to manifest itself and Charles's work undertook the change from that of a promising "boy artist" to that of an established master. As a couple, Charles and Marcia Woodbury painted side by side, sometimes collaborating, as in the illustrations for Marcia's

Charles Woodbury and his son David, c. 1900. Collection of Ruth R. Woodbury.

friend Sarah Orne Jewett's books *Deephaven* and *The Tory Lover*, and for a Houghton Mifflin edition of John Greenleaf Whittier's *Collected Poems*. When they were working on their own, they went in very different, but compatible, directions. His gift was for the depiction of movement and force in nature, especially in the sea and mountains. Her gift was for people, particularly for beautiful, serene, meditative faces. Her best subject was the villages and people of Holland, the almost archetypal Dutch look that goes back to the northern Renaissance. She painted everyday people imbued with an ideal beauty that had changed little in four centuries. Temperamentally and artistically, she was in many ways almost the opposite of her husband, which was probably why they did much better together as husband and wife than as teacher and pupil.

For the next twenty years, sometimes with Charles, sometimes with just their son David, born in 1896, Marcia returned again and again to Holland to paint the people and their children. Though she never received her husband's full degree of acclaim, her work was exhibited and honored in its own right in both Europe and America. Her awards included medals at the Atlanta exposition of 1895 and the Tennessee centennial of 1897, and the newspaper reviews of her joint exhibitions with Charles praise the serene beauty of her Dutch paintings. In at least one exhibit in 1895, in which first place went to Walter Launt Palmer, a watercolor by Marcia won second prize of $150 while one by Charles won $100 for third.

According to her son, Marcia "spoke and wrote Dutch like a native, and published many critical essays on Flemish and contemporary art."[7] But after a few years of happy work and family life, Marcia's health began to fail. Despite blinding migraines and long ordeals of almost unbearable general pain, she continued to paint, exhibit, and travel. David was with her once "in a small Dutch hotel when she became so sick she could not move." On returning home, she refused to retire, "but plunged again into long hours of struggle, this time to capture on paper and canvas the essence of her own New England people. Often staggering with fatigue and pain, she painted resolutely, now with a swift, sure touch, and when she could not longer walk to and fro before her easel she threw herself on her bed and wrote furiously, or made sketches of me for the portrait she was determined to do. She must have known by then that her time was running out."[8] She died in November of 1913 at the age of forty-eight, and Charles Woodbury had the single word *valiant* carved on her tombstone.

Although both Charles and Marcia were as dedicated to their art as anyone could be, they were also loving, devoted parents. David's first recorded memory was of riding on his father's shoulders, grasping his father's beard, as they set out over the rock ledges near their Ogunquit studio. When both Charles and Marcia wished to paint, Woodbury would sometimes tether his toddler son to a stake in the ground. When Marcia objected that the poor boy would sooner or later wind himself up in the rope—on which point she was immediately proved correct— the ingenious M.I.T.-trained artist at once came up with the perfect solution—two stakes and a pair of ropes! The parents could now paint and the child could amuse himself endlessly in games of wind-up and unwind between the ropes.

David later wrote: "I was brought up not to paint. Father said that

two artists in one family were enough."[9] Like his father, David received his education at M.I.T. and applied his education not to engineering but to art—in this case, writing. In hundreds of articles and books over a long career, David Woodbury exercised his inherited talent and the Woodbury love of inventions by explaining to the layman the wonders of twentieth-century science and technology. His sensitive, loving memoirs of both his parents testify to the depth of the care and love he received from them.

Career versus family, science versus art, tradition versus innovation—all these sometimes conflicting polarities seem to have been nicely balanced in the Woodburys, combined rather than opposed, lending fruitful complexity instead of disruption to both their life and their work. No one is perfect, though, and the Woodburys—Charles, Marcia, and David—no doubt occasionally experienced friction in their multifaceted relations. Indeed, the presence of in-laws as babysitters may have seemed too much of a good thing at times, leading to the construction of a beautiful but separate and quarter-mile distant studio for Marcia, where she could work while grandfather Seth and grandmother Mary entertained David. But in considering the biographies of other comparable figures in early-twentieth-century art and literature, the Woodburys seem more fully developed than most in manifold artistic, intellectual, and personal qualities, more stable and complete—rounder, perhaps, and better balanced.

III

'I Enjoy Anything which Has the Flavor of the Salt Air in It'

On his first European trip, the year of his marriage, Woodbury, like nearly every other American artist of his generation, studied for a few months at the Académie Julian in Paris with Bouguereau and Lefebvre. This was the only extended academic instruction he ever had in art, and he probably gained more from the contacts with other artists at the academy than from the actual instruction. He was and always would be essentially a self-taught artist, but he was not an artistic isolationist. Over his career he knew, exhibited, shared jury duty, and was on good personal terms with most of the important European and American artists of the period 1890-1940. The freshness and individuality of his art, his knowledge of and respect for, but personal resistance to, all the movements and fads that swept over modern art during his lifetime, were chacteristics always noted by those who wrote about him. So while Woodbury no doubt picked up some things at the Académie Julian, he probably gave as much as he got there.

During the early nineties, between trips to Europe, Woodbury maintained a studio in Boston, but he and Marcia also spent large blocks of time with the Oakes family in South Berwick. Exhibitions of oils and watercolors that he and Marcia had painted in Holland were warmly received. One 1892 commentator wrote: "At Chase's Gallery is a showing of water colors and pencil drawings by Charles H. Woodbury and Marcia O. Woodbury that astonish the visitor—the art visitor. . . . This display is far and away from the conventional; it makes one jump with pride to know that these works are from Boston painters' brushes."[1] And from another reviewer: "Many of the modern Dutch painters have devoted themselves successfully to the delineation of child life, but there are few among them, even of the most skillful, who have succeeded in portraying the real Dutch youngster as

he is more completely than Mrs. Woodbury. . . . Mr. Woodbury's landscapes are equally truthful and devoid of extravagance, and they convey a perfectly accurate and trustworthy impression of the most interesting phases of Dutch scenery. . . . Mr. and Mrs. Woodbury have spent three summers in Holland, and we know of no one, unless it be Mr. Tuckerman, who has been able to do fuller justice to the eminently paintable qualities of the country." [2]

In Holland, Woodbury painted many of the same kinds of landscapes that he had painted along the North Shore of Massachusetts: low horizon, large sky, dunes, small fishing village huts, nothing dramatic, everything lifelike without seeming overly literal. A reviewer unfamiliar with Woodbury's earlier, New England landscapes wrote that both Charles and Marcia "have done most of their studying and work in Holland, and are thoroughly imbued with the Dutch spirit, the Dutch method, and the Dutch landscape. The result is that the artists are highly finished as regards this particular style of work, but it is yet to be seen whether they can paint any subjects not Dutch."[3] But in an interview from the same period, Charles made it clear that whether in Holland or in America, he was not so much interested in defining particular topographies as in painting anywhere so long as it was outdoors and near the sea: "All of my best pictures have been painted out-of-doors. . . . I might say that all of my knowledge has been gained in the open air, since I have never attended art schools but have studied most carefully all the conditions of landscape painting from the scenes themselves." When asked why he so much enjoyed painting subjects, such as New England landscapes and Colonial houses, that other artists found uninspiring and unpicturesque, he replied: "I believe there is no place better than New England for the landscape painters. . . . One may make much out of a New England landscape. All depends upon the way the painter looks at his material." Even plain white farm houses: "There is no necessity for painting them stiff and unpicturesque," he said. "Colonial houses are often the best subjects. As for white, that is one of the most advantageous colors that exists, as white in shadow is beautiful. . . . I enjoy anything which has the flavor of the salt air in it. Even when the sea is not in view it gives a different tint to all regions in the vicinity. The color of the foliage is affected by the air and the whole landscape receives its imprint from the sea savor."[4]

Whether in Holland or in New England, then, Woodbury was more interested in the feeling, the atmosphere of the seaside villages and

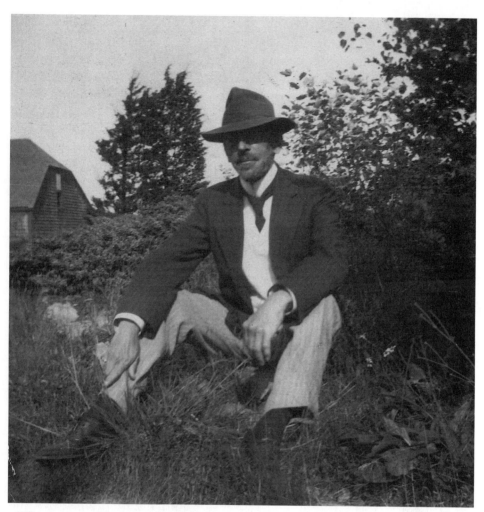

"He was very distinguished looking . . . and not very tall, but he held himself well and he was an imposing figure. He wore knickers and sneakers so he could walk over the rocks without slipping. Practically always formally dressed with a tie and nice shirt, a wool jacket . . . he looked like an artist. His hat was pulled down somewhat, wide brimmed. It made him look distinguished." Ruth R. Woodbury, quoted in *Ogunquit, Maine's Art Colony: A Century of Color: 1886-1986*, p. 15. Collection of Ruth R. Woodbury.

beaches than in depicting specific objects. Any subject, no matter how common or humble, could be made into art, "depending upon the way the painter looks at his material." By 1892 he was well known as a master of a certain kind of seaside painting, whether set on this or on that side of the Atlantic.

But it was in 1893, on his third trip to Europe, that Charles began the painting that would lift his reputation to a significantly higher level. He made his first sketches for *Mid-Ocean* in September, on the voyage to Antwerp, on a day of very rough seas, by "wedging himself under a life-raft near the stern, holding the canvas down on the deck with his elbows, and painting with a wrist movement."[5] He finished the monumental four- by-six-foot painting in Laren in 1894, and first exhibited it that spring under the title *Serpente Verte* at the Paris Salon. William Howe Downes, after a hundred years still one of Woodbury's most astute and sympathetic commentators, writes: " 'Mid-Ocean' may be said to be Woodbury's first serious effort to convey a personal impression of a great motive—nothing less than the majesty and beauty of the sea. . . . the first of a series of works in which his chief purpose has been to give expression to the idea of force."[6] A writer in the *Boston Transcript,* probably also Downes, on January 23, 1895, says: "Woodbury's picture is great because it is a serious and successful effort to suggest a great theme; because it is the truth of nature intelligently and feelingly stated; because, in a word, it is a fine hint of that fine thing, the vastness, power, beauty, and majesty of the ocean."

From *Mid-Ocean* on, Woodbury's sea paintings would be compared seriously to those of the great American marine painter who had given the young Woodbury his first public award, Winslow Homer. As Downes writes in a *Boston Evening Transcript* column for February 9, 1900: "The connection of any painter's name with that of Winslow Homer, in serious criticism, implies that he stands on very high ground. Mere imitation of the surface qualities of such a master would be grotesque and pathetic. . . . The resemblance which we see in the works of Woodbury is wholly of the spirit, not of the letter." Thus, by 1895, at age thirty, Woodbury was married, well traveled, and celebrated on both sides of the Atlantic as one of the leading American painters of the day. His next move would make him a man of property and the founder of a school of art that still bears his stamp and influence, though not his name, more than fifty years after his death.

IV

'Beautiful Place by the Sea'

Woodbury first saw Ogunquit in 1888 on a visit to the Oakeses' summer house in York Beach, Maine. "As he rounded the last hill, he reined in the horse. Across a peaceful cow pasture and corn field, he spied a group of fishermen pulling their nets from a lazy winding riverbed. Their colorful dories were anchored in a rocky inlet nearby and their plain shacks bespoke a simple lifestyle that moved him."[1]

At that time, visitors from Boston and New York could travel to York, Maine, by train, but the trip to Ogunquit required a seven-mile carriage ride north over a dirt road along the shore. The center of town, about a mile from the harbor, consisted of a store and stable and a few houses. At the mouth of the Ogunquit River, fishermen's shacks clustered around the wharves where schooners bound for Boston and beyond loaded salt, lumber, and fish. Later in the summer of 1888, Woodbury rented a room at Captain Littlefield's house on Shore Road, where a few rooms were available for the small number of summer tourists who then came to the still unspoiled village whose name in the language of the earlier Native American inhabitants is said to mean "beautiful place by the sea."

Over the next few years Woodbury returned to Ogunquit several times. Then, after David's birth in 1896, he paid Jedediah Moses Perkins $400 for five acres of rock ledge and pastureland off Shore Road (part of which is now the site of the Ogunquit Museum of American Art). Where a small fish house had stood, Woodbury built his first studio overlooking the cove. Two years later he built a rambling wood- shingled Victorian house with enough rooms that his parents could live with the family through the summer to help take care of David. Later, as previously noted, he built for Marcia a separate studio, later home to David's family, near Shore Road.

Though one of the first, Woodbury was not the only artist to dis-

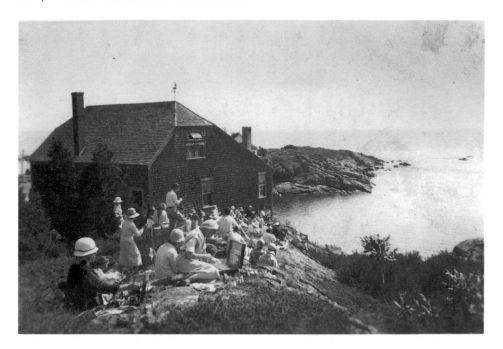

The studio later served as exhibition space for Woodbury's paintings and headquarters for his art school. Collection of Ruth R. Woodbury.

cover Ogunquit before 1900. Others who painted there include Maurice Brazil Prendergast (1859-1924), Dwight W. Tryon (1849-1924), Frederick Porter Vinton (1846-1911), and Robert Louis Stevenson's close friend Robert Arthur (1850-1914). But it was chiefly Woodbury's magnetism that turned Ogunquit from a sleepy little fishing village into an important American art colony. In 1898 Woodbury offered his first six-week course in painting at Ogunquit, with two weekly lessons and a lecture-critique every Saturday. The art school was an enormous success: Sixty to a hundred students came every summer—men, women, beginners, professionals, many from Boston but others from all parts of the country, all setting up easels around the village and along the rocks and dunes.

Ogunquit—its beaches, tourists, and inhabitants—became one of the best recorded vacation spots in American art. The stretch of sand with dunes in the background, beach umbrellas, small figures, usually mothers and children, in turn-of-the-century bathing caps and costumes, water, sky, a few clouds and a low horizon. This is the Woodbury school Ogunquit beach scene rendered by him and any number of his able followers. Woodbury's wealthier pupils bought their own houses, built their own studios, invited more friends, and soon artists and art lovers outnumbered the farmers and fishermen whose simple way of life the early artists had come to paint.

Woodbury's calm, patient manner and his practical but carefully planned pedagogical methods became a model for later art educators. As a newspaper clipping from around 1900 tells us: "His theories of painting (having a scientific quality of mind), combined with his practical demonstration in the great pictures he paints, have given him an authority on the subject which it is safe to say is entirely unparalleled in any other 'institution' of its kind. He does not work by criticisms, but by opening the pupils' eyes to principles. On Saturdays he has a 'concours,' criticising and enlarging upon the work that the students have done alone during the week. Each time he gives what may be called a problem, the object of which is to train their observation and powers of concentration, etc.; in fact for picture making. This feature is unique. Pupils come back, even as far as Boston, and no one is admitted who is not a pupil, outsiders frequently apply to become a member of the class (who do not paint) for the sake of hearing this lecture. He also has a very large special class in the winter for teachers, which proves to be of great benefit to them."[2]

A few years later, in 1906, another writer describes Woodbury at

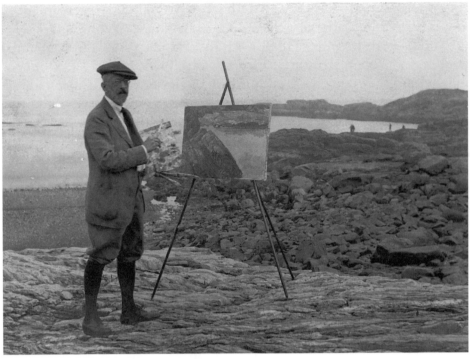

Throughout his career Woodbury maintained that all his best painting was done out of doors. Collection of Ruth R. Woodbury.

work as a teacher: "Twice during the class session, he paints in the open while the group of students look on. He starts the picture on the bare canvas, and it grows before the eyes, to the finish. After it is completed numbers are distributed, and the excited pupils draw for the sketch, no one being allowed to win twice."[3] At the end of the summer school session, Woodbury would open the studio to visitors every afternoon for a weeklong exhibition of both recently finished pieces and works in progress. Sales from these little private shows made a handsome supplement to the money he received from prizes and gallery exhibitions.

At the end of summer, after the students and tourists departed, Woodbury often stayed in Ogunquit to paint through the long Maine winter. This, probably more than the paintings, earned him the respect of the local people. A newspaper from around 1910 has the headline: "ARTISTS ENDURE HARDSHIPS. Painting Pictures in Zero Weather." The writer tells us: "Among the men at the fish house a quiet smile went round when Mr. Woodbury first appeared with his paint box and canvas and the request for two men to 'hold him off the rocks' in a

dory in a tempest of wind and rain. 'He will be back quick,' they said. But he was not and they had to admit that a city man could stand exposure and hardship as well as the best of them. The winter of 1905 and '06 Mr. Woodbury spent at Ogunquit working out of doors, many a time when the thermometer ranged near zero. It would seem to most people an impossibility to stand in the deep snow and work barehanded for three or four hours at a time; but a painter, be he earnest enough, regards little material discomfort so long as he is able to record the beauties he sees. With a short wool-lined coat and a hat that covers the ears, he avoids the actual danger of frost bite, and for the rest he can warm up after his sketch is done."[4]

As noted earlier, Woodbury often said that his best painting was done outdoors. He painted in all kinds of weather and in all kinds of locations, often making unsettled weather conditions an important part of the composition: Rain, fog, mist, high clouds, wind, changing tides, and melting snow all make frequent appearances in Woodbury's paintings. He often painted the same shores and hills as did the American Luminist artists of earlier generations—Fitz Hugh Lane, John F. Kensett, A.T. Bricher, W.T. Richards—but Woodbury's emphasis is on the beauties of nature in motion rather than in repose. Where earlier generations of artists, especially those of the Hudson River School, conveyed a sense of awe before nature by painting the most dramatic or exotic scenes possible, Woodbury communicates a similar sense of awe but in the presence of the barest natural elements. In the mature Woodbury the forces at work within mundane reality become as interesting and as spiritually imbued as spectacular scenery was in the works of earlier romantics. The rock shelf in the pasture becomes, for Woodbury, as facinating as the high domes of Yosemite, The ocean seen from the back of the boat seems as worthy of art as surf crashing against the cliffs of Cornwall; the woods on the back road inland toward North Berwick can be as emblematic of natural force as the Amazon rain forest. In Woodbury's treatment of nature, it is not the external dimensions but the internal forces that create the dramatic interest. As Donald Krier has noted, in discussing the painting *Monadnock*:: "Woodbury, ever experimental and analytical, suggests that the mountain, like the wave, implies motion. Mountains and waves result from struggles—waves fighting water, mountains fighting land. To him, 'motion is a time relation between masses.' Ancient struggles inside the earth made mountains of motion. Only time differentiates the motion of the wave from the mountain's motion. One feels

as well as sees in Woodbury's *Monadnock* of 1912 waves that are mountains and mountains that are waves."[5]

Whether he painted the waters, trees, and dunes of Maine or scenes of Holland, Woodbury remained essentially a Boston artist: thoroughly academic, insistent on technical mastery, more interested in extending traditions than in trying to break beyond them. His view of the artist was unapologetically elitist, showing no patience for "those who appear to be interested in drawing and painting as an accomplishment only. . . . If I had my way about such matters, the guiding of young men and women in the fine arts, I would first ascertain if the subject possessed any qualifications for the profession, that is, if he or she were artistically inclined; to such I would say, 'the road to success is a long one and almost impossible to travel; serious application, patient waiting, and for twenty years no recognition, is your outlook. To some ladies, I would suggest embroidery, lace work, or other like domestic employment, to some gentlemen, a trade."[6] Art was for the serious, the dilligent, the properly trained—certainly not for dabblers, dilettantes, barbarians, or shock-seeking experimentalists.

V

'Academics' and 'Bohemians'

Fortunately, they were neither dabblers nor barbarians, but in 1902, some of the early forerunners of American experimentalism moved into Woodbury's Ogunquit. The first was the wealthy artist, critic, and patron of modernism Hamilton Easter Field (1873-1922), who brought with him a young protégé from France, the future sculptor Robert Laurent (1890-1970). Over the next few years, Field, whose mother was an heiress from the Haviland china family, bought what was known as the Island House and most of the land on the north side of the cove, and there established a school and colony devoted to a brand of art that lay—and not only on the local map—on a shore opposite Woodbury's. Aesthetically rooted in New York instead of Boston, diversely cosmopolitan instead of old-line Yankee, valuing experimentation over tradition, novelty over continuity, expression over representation, imaginative play over technical rigor, promoting and contributing to the 1913 Armory Show rather than the annual exhibitions of the Copley Society and the National Adademy of Design, the Field group produced a body of art similar in subject but very different in spirit from that of the Woodbury school. Yasuo Kuniyoshi, (1893-1953), for instance, painted the local cows; Marsden Hartley (1878-1943) the nearby hills and mountains; Bernard Karfiol (1886-1952) women by the water; John Marin (1870-1953), the action of waves—all familiar Woodbury subjects, but in a manner and spirit far removed.

As Robert Laurent's son the painter John Laurent remembers, the Field "bohemians" sometimes liked to try to shock the Woodbury "academics": "One day a young European countess who modeled for at least one summer at Field's school, jumped up from a nude pose, grabbed an Oriental kimona, and, dashing across the little rickety bridge to the other side of the Cove, flung herself nude on the steps of Woodbury's studio and proceeded to sunbathe."[1] But Woodbury and his group were not stuffy prudes. Woodbury himself sometimes drew

or painted nude bathers (see his etching "Sea Pool") and many of his pupils did the same. The difference appears to be that on the north side of the cove, the painting of nude models seemed a social statement intended to shock an assumed bourgeois sense of propriety, whereas on the south side the nude was simply another traditional natural subject for art, going back at least as far as classical Greece. As Bernard Karfiol's son George wrote: "True, the two schools had differences, but I don't think there was any particular 'bad blood' between them; they just went their separate ways. The Field school seemed to have a younger, fun-loving group who took to dancing a Valentino tango or just playing the latest records. Whereas the Woodbury-ites seemed older, quieter, and more sedate."[2] Similarly, to the Woodbury side, the "Field-ites" probably just seemed younger, noisier, and a bit more boisterous, but certainly not "the enemy." For Woodbury, the proximity of the Field school provided a close-up view of modernist expressionist and abstract tendencies that he would adopt for his own art in moderation but not follow to the extremes he could see across the cove.

The "older, quieter" students on the Woodbury side included several who have subsequently been recognized as leading American women traditionalist artists of the period. Gertrude Fiske (1878-1961) was the daughter of a prominent Boston lawyer, a member of an old New England family directly descended from Gov. William Bradford. Athletic as a girl, once even the winner of the Massachusetts Golf Championship,[3] Fiske studied under Edmund C. Tarbell (1862-1938), Frank W. Benson (1862-1951), and Philip L. Hale (1865-1931) at the Boston Museum School, and was one of the first to complete the full seven-year program. Her family's wealth "allowed Fiske the freedom to paint where and when she wished, without added frustration."[4] From about 1912, when she finished her studies at the Museum School, she began a long association with Woodbury, attending his Ogunquit summer classes and eventually buying a summer home and studio on Pine Hill Road in town. Though her portraits and figure paintings show the influence of Tarbell and Benson, her landscapes and beach scenes reveal her very considerable debt to Woodbury. A winner of many prestigious medals and prizes, and elected to the National Academy in 1922, Fiske was probably Woodbury's best-recognized and most successful pupil.

Other women "Woodbury-ites" whose names are familiar today include Mabel Woodward (1877-1945), Margaret Patterson (1867-1950), Susan Ricker Knox (1874-1960), Anne Carleton (1878-1968), Charlotte

Butler, Amy Cabot, Elizabeth Sawtelle, and Grace Morrill. The young men who worked with Woodbury and later achieved reputations of their own as artists include Edward R. Kingsbury (d. 1940), Parker Perkins (1875-1949), Elwyn George Gowen (1895-?), and Raymond M. Crosby (1876-1945). Beach scenes with umbrellas and figures, minimal landscapes with a low horizon and moving clouds, treeless but color-fully veined mountains, and seascapes featuring swirling waves and tidal flows with pinks and sometimes yellows added to blues and greens—these are the marks of the "Woodbury school" works painted by the artists listed above and others. Some works by the pupils, such as Mabel Woodward's beach scenes, Anne Carleton's marshy fields, and Gertrude Fiske's minimal tree and shore studies, look almost more "Woodburian" than the master's, and today the best works by his fol-lowers sometimes receive more attention and fetch higher prices at auction than works of similar size and subject by Woodbury.

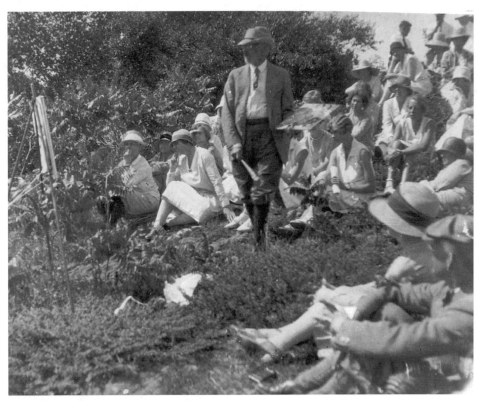

Woodbury admonished his students to paint not just the person but what the person was doing. Collection of Ruth R. Woodbury.

VI

'A Place among the Greatest'

Over the first three decades of the twentieth century, Woodbury's reputation grew with each new exhibition. In a 1911 article titled "Recent Tendencies in Marine Painting," the artist and author Birge Harrison (1854-1929) lists among the best: "C.H. Woodbury, who has even outdone Homer in the sense of resist-less power, of relentless and crushing force which he gives to his waves."[1] Another artist and author, Arthur Hoeber, wrote in the same year (but for a different publication): "Mr. Woodbury builds on the lasting foundation of truth, as mighty in art as in the great world else-where, without which nothing can prevail; his canvases possess those convincing qualities not otherwise possible. The newer fads in art have passed Mr. Woodbury unscathed. He has gone his way with the obvi-ous desire to render that which he saw and felt, regardless of momen-tary digressions, new tricks or novel fashions in using his pigment. Therein, too, he has much in common with the methods of the late Winslow Homer, though his color sense is far more delicate. His eye is very keen for relations, for the subtle nuances of light and shade, and he is a painter who spends perhaps more time in the contemplation of his theme than he does in the actual putting on of the pigment."[2]

These comments by writers who were themselves accomplished painters indicate that, in addition to all else, Woodbury was very much a painter's painter. In 1883 he was the youngest member ever elected to the Boston Art Club. In 1899, he was elected to the Society of American Artists; in 1900 he was chosen president of the Watercolor Club of Boston, in 1906 he was elected an Associate of the National Academy of Design and the following year was elevated to a full member of that distinguished body. All these honors were accorded by his fellow artists. Prizes that he was winning outside Boston include: Gold Medal, Atlanta Exposition, Georgia, 1895 for *Mid Ocean* ; Second Prize, Tennessee Centennial, Nashville, 1897, for the same painting;

Bronze Medal, Pan-American Exposition, Buenos Aires, 1899, for *Maine Coast*; Bronze Medal, Exposition Universelle, Paris, 1900, for *Rock and the Shore*; Bronze Medal, Panama American Exposition, Buffalo, 1901, for *Maine Coast*; First Prize, Worcester Art Museum, 1903, for *The North Atlantic,* Silver Medal, St. Louis Exposition, 1904, for two marine paintings; Honorable Mention, Carnegie Institute, Pittsburgh, 1905, for *The Cliff;* Silver Medal, Buenos Aires Exposition, 1910; Evans Prize, American Watercolor Society, 1911, for *Evening;* Second William A. Clark Prize and Corcoran Silver Medal, 1914, for *Rainbow;* Gold Medal, Panama Pacific Exposition, San Francisco, 1915, for *Rainbow;* Medal of Honor, Panama Pacific Exposition, 1915, for a watercolor; Dana Gold Medal, Philadelphia Watercolor Club, Pennsylvania Academy of Fine Arts, 1923; the Henry B. Swope Prize, Society of American Etchers, 1931, for *Running In,* The Palmer Marine Prize, National Academy of Design, 1932, for *Changing Wind,* and the Noyes Prize, American Society of Etchers, 1933, for *Ledges.*

During these years he held one-man exhibitions, showing anywhere from twenty to sixty works at such galleries and museums as: the J. Eastman Chase Gallery, Boston; St. Louis Art Museum; Wellesley College; Doll and Richards, Boston; Art Institute of Chicago; Cincinnati Museum; Bradford Academy; Durand-Ruel Galleries, New York; St. Botolph Club, Boston; Utica Public Library, New York; Guild of Boston Artists; Milwaukee Art Institute; Portland Art Museum, Maine; Rhode Island School of Design; Vose Galleries, Boston; Albright Art Gallery, Buffalo, New York; Bates College, Maine; Detroit Museum of Art; Pratt Institute, New York; Copley Society, Boston; Panama Pacific Post Exposition, San Francisco; Library of Congress, Washington, D.C.; Grand Rapids Art Association, Michigan; Corcoran Gallery; Cleveland Museum of Art; The Grolier Club, New York; Grand Central Art Galleries, New York; Frederick Keppel, New York; Governor Dummer Academy, Massachusetts; Columbus Gallery of Fine Arts, Ohio; Addison Gallery of American Art; Rochester Athenaeum; Winchester Public Library, in Massachusetts; American Federation of Art; Museum of Fine Arts, Boston; and the Boston Athenaeum.

Local newspapers devoted considerable attention to Woodbury's exhibitions. Typical is this article by William Vernon from a Chicago paper of 1902:

> The most vital things that have come out of Boston for a long time are the pictures of the sea by Charles H. Woodbury, now being shown at

O'Brien's galleries. Mr. Woodbury has achieved, in the last few years, a place among the greatest of American marine painters—he occupies a sort of middle position between Winslow Homer and Alexander Harrison. At times he reaches the tempestuousness of the one and again the serenity of the other. Mr. Woodbury leads the most strenuous life of any painter in America today. He paints almost entirely out of doors. Clad in oilskins and a sou'wester, he braves the storms of the Maine coast with his color box strapped to him, and many times his easel nailed to the deck. He treats his colors chemically to keep them from freezing, and paints with heavy woolen gloves on in the very teeth of the gale. While the stern of his boat is rising and falling forty feet or more, he paints the swirling wake. The north wind bites into the eyes of the sailors, but the sea never blinds the glass of this artist-mariner. The movement of the water is fairly placed upon the canvas, and it is keenly felt by the observer. . . . Mr. Woodbury has grown wonderfully in a few years. From time to time his pictures have been seen at the Art Institute during annual exhibitions of American artists, but nothing heretofore has approached in power the pictures in the present exhibition. For a number of years Mr. Woodbury painted the Dutch landscape vigorously . . . but the sea has called him and he will be known to posterity as a marine painter. Mr. Woodbury lives nine months a year near Ogunquit, Me. where he has built a studio 200 feet from the beach and about the same height above it. Here he comes as near the "God of the open air" as a mortal is permitted.[3]

Similar articles accompanied other exhibitions in other years in the papers of Philadelphia, New York, St. Louis, Cleveland, Indianapolis, and Cincinnati. Celebrated almost as much for what would today be called his "work ethic" as for his paintings, Woodbury was known all over the country as the Maine artist who painted outdoors in temperatures below zero, who fastened himself and his equipment to a pitching boat, the better to paint the turbulent waves, the trained engineer who used his knowledge of chemistry to keep his paints from freezing or running while he painted in heavy weather. A tireless perfectionist, a demanding master, a believer in hard work and high standards, Woodbury enjoyed the reputation from start to finish of a devoted professional who viewed art as a serious and worthy enterprise.

When in his view the public failed to recognize the true value of art, either by underprizing good work or by overprizing bad,

Woodbury did not hesitate to set matters straight with a succinct letter to the editor. For instance, in a 1922 letter about the lofty praise given a recent exhibition of children's art, Woodbury began: "To the Fine Arts Editor—In view of the general interest now being taken in children's sketches, it is well to consider their true value and not to over-estimate their importance as an accomplishment." He points out that their charming "simplicity is gained through ignorance rather than special talent and has a misleading resemblance to the simplicity that talent attains through knowledge." And after dealing with a facile comparison that someone made between children's art and Japanese woodblock prints, Woodbury concludes: "One would surely not minimize the value of children's efforts to express their thought in color or line, but on the other hand it would be a damage to their further development to give these drawings a place to which they are not entitled."[4]

In 1897, though, when Woodbury thought that Abbott H. Thayer's great painting *Caritas* was being overlooked by the acquisition committee of the Boston Museum of Fine Arts, he made both spoken and written public appeals on behalf of the picture:

> I wish through your columns, to call the attention of your readers to the fact that there is at present hanging in the Art Museum one of the finest pictures ever painted by Mr. Abbott Thayer. To say this is to name it as one of the greatest pictures of our time, for Mr. Thayer's position in the art world is a matter beyond question. He is one of our really original painters, and it is through his efforts and through the efforts of men of his stamp that we are soon to have what we have so long been awaiting—an American School. The opinion of artists in regard to this, his latest work, is well nigh unanimous—it is one of the few modern pictures that will live. No one may afford to lose the opportunity of seeing it. A pity it is that we cannot say that it will find a permanent place on the walls of our museum, serving as a guide and inspiration to all who care for art and beautiful things. Through it the Museum would establish a claim to consideration that at present the Library only possesses. We have many good pictures there, but as yet, with one or two exceptions, no great modern ones. How can we afford to neglect the influence of living art when that is what concerns us directly? We must have the work of former masters, but can its influence be so important as to exclude that of the masters of today, who have learned the lesson of the past and have added to it the wisdom of the present? We have also a personal responsibility in the mat-

ter, for we owe a debt of gratitude to the men who gave us such stan-
dards of art, and a hearty recognition of that debt is the duty of every-
one. Let us have in our museums the best work of our great painters
and in recognizing their true value honor ourselves. They should not
be mere storehouses, but should exert a living, active influence by
placing before the public the recognized standards of modern art.[5]

Woodbury shows here both his admirably unselfish support for the
work of a fellow artist and his sincere belief in the beneficial influence that
great art—and the standards that accompany it—should exert on society.

And in another example of his public statements on questions of
social concern, Woodbury in 1938 spoke out strongly against the newly
proposed idea of federal subsidies for artists, which he considered
"one of the most destructive ideas yet advanced." In reaction specifi-
cally to the Coffee bill, which called for the establishment of a federal
bureau of fine arts to serve as an employment agency for Works
Progress Administration (WPA) artists, Woodbury asserted: "Any
artist who can't earn a living painting should not be subsidized to con-
tinue at a hopeless task producing mediocrity."[6] In fifty-seven years of
painting, he added, he "took any painting job that came along and I
was willing to take any other kind of job that would enable me to earn
my living and keep on painting." This is more than simply an old
man's rant against newfangled ideas. Woodbury seriously believed
that only long struggle results in significant art and questioned any
policy that would offer the reward without the appropriate effort, that
would make success in art quicker or easier for anyone, regardless of
talent or effort, to attain. Aesthetic standards, not political sympathies
or connections, were paramount. Woodbury trusted the judgment of
the market and of fellow successful artists over the opinions of officials
politically appointed to any proposed government arts bureau.

Since the beginning of his career, Woodbury had moved easily
within the nearest circles of leading fellow artists. As a boy he had
worked with the main Lynn artists, exhibiting with Burrill and taking
sketching trips to Canada and sharing gallery space with C.E.L. Green.
When he became a Boston artist, he was not in the group known as
The Ten, but he befriended, painted, and exhibited with Childe
Hassam, Frank Benson, J. Alden Weir, Thomas Dewing, Edmund
Tarbell, and others in that group. After his election to the Society of
American Artists, in 1899, and to the National Academy of Design, in
1906, his circle of artistic friends and colleagues broadened to include

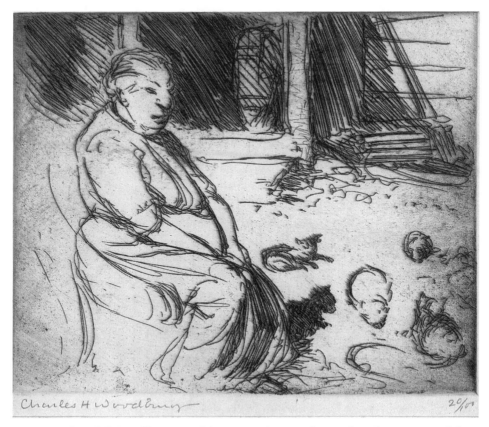

Charles H Woodbury 20/00

"Mrs. D," and "Men Clamming" (next page) are etchings that share some of the qualities of his deft figure sketches in crayon. Collection of George and Patricia Young.

figures of national and international prominence. A 1915 newspaper photo, for instance, shows Woodbury at the Panama Pacific Exhibition "bringing honor to Massachusetts" with, among others, fellow artists Phillip Little, John J. Enneking, Cyrus Dallin, Herman Dudley Murphy, and Edmund Tarbell. Another photo, from 1922, shows him with Charles C. Curran, the two having been elected judges for the twenty-first international Carnegie Institute exhibit. Another photograph, from about the same time, shows him with other fellow jurists, the nationally prominent artists Daniel Garber, George W. Bellows, Charles W. Hawthorne, Bruce Crane, Emil Carlson, Edward W. Redfield, and Leonard Ochtman. And yet another photo of an international jury shows Curran and Woodbury arriving in Pittsburgh with the eminent French artist Lucien Simon and the equally distinguished British artist Dame Laura Knight. In 1921, in perhaps his best-known

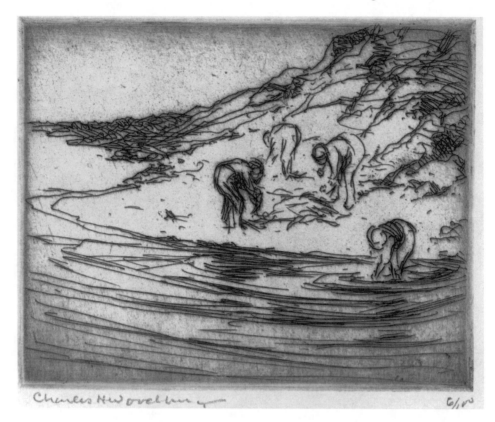

Charles HW ovelbur 6/100

interaction with a fellow artist, Woodbury and John Singer Sargent painted each other's portraits. Sargent's painting of Woodbury is now in the National Portrait Gallery in Washington, D.C., but the location of Woodbury's portrait of Sargent is currently unknown.

One of the highlights of Woodbury's career came in 1911, when Queen Mother Margarita of Italy saw and purchased his watercolor, *A Tropical Sea,* at the American pavilion of that year's International Art Exhibition in Rome. The negotiated price was not disclosed, but the proceeds enabled Woodbury to add a nice carriage house, which he named The Windfall, to his home in Ogunquit.

Woodbury was in his day ranked one of the very best American artists. Over the remainder of his life the quality of his work did not diminish. It was only after his death, as tastes in art changed, that his accomplishments were gradually forgotten and he ceased to be accorded the stature of a major American painter.

How the Women Went from Dover, the Woodbury illustration based on a Whittier poem which in turn was based on an event in early New Hampshire history. Collection of Dover Friends Meeting House.

VII

'The Beauty and Integrity of Things Seen'

Though not the kind of work he was best known for, Woodbury's paintings and drawings of people are wonderful. He was a master at formal portraits, such as those of his mother, Mary, his friend and fellow artist John Singer Sargent, and his later associate and collaborator Elizabeth Ward Perkins; but his real knack was for quick sketches of figures in motion. When away from his studio, he liked to carry packs of five-by-seven inch drawing cards on which he would record, usually with a grease pencil, any action that caught his eye. At lunch at the St. Botolph Club in Boston, if he ran out of his own cards he would use menus—he sometimes executed half a dozen drawings before the waiter he was sketching finished serving the soup. He could sketch at least four stages of the struggle before a new arrival could squirm out of a winter coat. By the hundreds, he sketched dogs asleep and dogs scratching, pigeons pecking, workers bearing heavy loads, figures lying on the sand gazing out to sea, other artists sketching, people eating, talking, or sitting on a rock. The Boston Public Library has a huge collection of these marvelous sketches. Jonathan's Restaurant in Ogunquit also has a fine selection of them permanently on view for visitors and diners.

Another, less-well-known side of Woodbury's art is the work he did, sometimes in collaboration with Marcia, as a book and magazine illustrator. In 1893 the Woodburys illustrated *Deephaven*, by Marcia's friend Sarah Orne Jewett. Set in a Maine shore town combining features from Ogunquit, South Berwick, Wells, York, and Kittery, the story tells of two young women who immerse themselves for a summer in a small-town New England way of life before returning to Boston and the larger world. Both the story and the illustrations are based on people and buildings in South Berwick. Marcia's mother and father modeled for the illustrations of the Widow Tully and Mr. Lorimer; Charles

"Ogunquit fisherman" is an example of one of Woodbury's quick sketches. Collection of Ruth R. Woodbury.

Woodbury's mother sat for the drawing of Mrs. Patton, the Widow Jim. The Hamilton House, and the Jewett and Oakes houses, all familiar landmarks in South Berwick, served as models for architectural interiors and exteriors in the Woodbury illustrations.[1] The paintings for *Deephaven* work as illustrations both of the book and of the vanishing way of life that the book depicts. The people are those whose dress and manners were formed in and still informed by an earlier generation, people in small New England towns in the late 1870s still living as if before the Civil War.

For another group of illustrations, commissioned to accompany the publication of the 1904 Houghton Mifflin "Household Edition" of John

Greenleaf Whittier's *Complete Poetical Works,* Charles and Marcia
Woodbury had to use their historical imagination to create scenes and
characters from a more distant past. In their illustration for "How the
Women Went from Dover," now in the collection of the Dover Friends
Meeting, they show the sad punishment in 1662 of three Quaker women
accused of witchcraft, stripped to the waist, tied to a cart, being driven
by the Puritan magistrate along a snowy wooded path. As in *Deephaven,*
the setting is local, but in this instance two centuries rather than two
decades in the past: The women are forced to march past the Cocheco
River, through Hampton and Seabrook, to Salisbury, where the defiant,
heroic Justice Pike refuses to carry out the remainder of the sentence.

The realistic quality of the illustration is striking: the sloppy wagon
ruts, the heavy dark Puritan garb of the men, the heavy skirts and bare
backs of the women. Even in this very unusual and dramatic scene—
witches being scourged!—the emphasis is on the familiar and undra-
matic surrounding details. The two riders ahead of the cart are not
looking back at the half-naked women, but, businesslike, looking at the
road ahead; the figure behind the women is not especially evil-looking
or malicious, but large-jawed and perhaps a bit thick, less a slave driver
than a limited man determined to do what he has been told it is his job
to do. The trees are not the grotesque, gnarled growths that we might
find in a melodramatic treatment of the subject, but normal, upright
trees surrounded by normal dirty snow. The accused witches are not
the crones of fairy tales, and not the demonic beauties of decadent end-
of-century fantasies, but three normal, healthy-looking women, two
wearing white bonnets, looking more like ordinary farm- or fishwives
who just happen to have their shirts off rather than like witches. If they
were not stripped to the waist, and if we did not know otherwise from
the context of the poem, the scene might be taken as a winter trip to
market—such is the marvelously realistic effect accomplished by this
juxtaposition of the ordinary and the extraordinary.

In a similar scene involving the expulsion of Quakers, the illustra-
tion for "The King's Missive," titled "So passed the Quakers through
Boston town," we see a large procession of men, women, and children
passing along a street with thatched houses, a windmill, and Puritan
spectators. The Woodbury insight here is that seventeenth-century
Boston probably looked very much like the nineteenth century
Holland they knew so well from their recent travels. And again, here
as in "How the Women Went from Dover," the sense of the everyday
real life pervades this extraordinary moment in distant American his-

tory. The people walking through the street have just had their death sentences commuted, but instead of bearing expressions of elation or relief, they just look tired, calm, patient, ready to bear whatever is ahead just as they were ready to accept the execution from which they have been spared. The spectators, in the poem,

Noisily followed them up and down;
Some with scoffing and brutal jeer.
Some with pity and words of cheer.

But in the illustration, the artists make the point that the observers are very much like the observed, Puritans like Quakers in dress, natural features, and expression. One spectator in the foreground is extending her hand toward a little girl in the procession, but the gesture looks more like one of sympathy than of jeering, and the expression on the face of her onlooking neighbor is pensive, perhaps troubled, as if showing her recognition that two groups, judging and judged, are not, after all, that different.

In both the Quaker poems, Whittier's literary text tends to be a bit more simplistic, using heavier lines to distinguish the heroic victims from the detestable victimizers, than are the Woodbury illustrations. The moments the Woodburys choose to illustrate are not those in which the judge accuses the victim, or the executioner prepares to wield his instrument, or the hero announces the liberating pardon, but the in-between time when ordinary life has to go on, the part that fits between the great highs of life and the great lows, the period when the guards as well as the cold, bare-breasted women have to slog through the snow, the part where the Quakers trudge along knowing they will not be hanged today but not knowing where or when they will stop for the night or what they will do for supper.

Another illustration touching on seventeenth-century assumptions of witchcraft in rural New England accompanies the poem "The Wreck of the Rivermouth," about a fishing party that sails out of the Hampton River seaward on a bright summer day. Passing the cottage of old Goody Cole on the point opening to the sea, one of the merry party unfortunately cries out "Fie on the witch!" To which Goody Cole replies:

"Oho!" she muttered, "ye're brave today!
But I hear the little waves laugh and say,
'The broth will be cold that waits at home;
For it's one to go, but another to come!'"

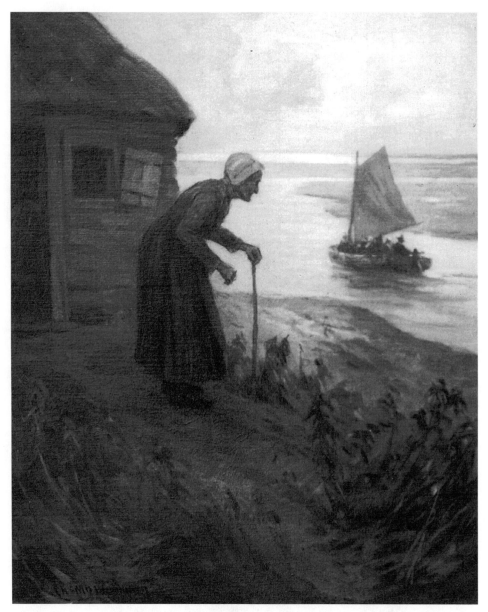

"Oho!" she muttered, "ye're brave today!"—Goody Cole's words are inscribed in pencil on the back of the canvas. Collection of George and Patricia Young.

Whether intended or not, Goody Cole's words operate as a curse. Later in the day, a brief sudden storm appears, capsizes the boat, and all are drowned. Though she feels remorse that her prediction has come true, the townspeople at the funeral view her as a witch and the cause of the disaster. As described by the skipper of the boat in the poem, she shakes:

Her wicked head, with its wild gray hair,
And nose like a hawk, and eyes like a snake.

The illustration shows an old, bent woman, not necessarily malevolent, hair, here neatly tucked into a bonnet, her nose not particularly hawklike and her eyes, if snakelike, turned so as not to be noticed by the viewer. The boaters are sailing from the mouth of the river toward the open sea, but at the moment, Goody Cole's position on a downsloping hill appears more precarious than that of the doomed boating party. She is leaning on a stick, and the caption written in pencil in Woodbury's hand on the back of the stretcher, " 'Oho,' she muttered, 'ye're brave today,' " seems in the painting less a curse than a muted exclamation of envy mixed with admiration, a lonely old person watching a band of merry young people heading for an enjoyable outing that she cannot share. There is nothing in the illustration to suggest that the old woman is a witch, no occult symbols, no pagan or demonic references. The scene is obviously in the seventeenth century: the boat, the clothing, the thatch on the cottage roof are all from two centuries before the Woodburys painted, but the scene is clearly the estuary around Hampton, the weeds and path are like those near many a derelict fisherman's shack along the New Hampshire or Maine seacoast, and the overall feeling of the illustration is of something familiar instead of something strange.

Still another illustration of a Whittier poem shows again the Woodbury gift of familiarizing the exotic. The poem is "Kallundborg Church," apparently based on an old Norse legend, involving a double bargain in which a young man, Esbern Snare, promises his baron that he will build a great church by the sea in return for the hand of Helva, the baron's beautiful daughter, then makes a second bargain with a troll: The troll and his little helpers will build the church but the young man must discover and announce the architect troll's name or forfeit his eyes and heart to be playthings for the troll's children. Eventually, after lovely Helva volunteers to give up her eyes, heart, and life so that her Esbern may live, he hears the troll's wife singing to her little trolls about the squishy new toys they will have the next day, the secret name of the architect troll comes out in the song, and all ends well: Baron gets church, young lovers Esbern and Helva get each other, trolls get disappointed children and domestic strife. The moment Woodbury choses for the illustration has Esbern gazing at the nearly completed church. But all the exotic or melodramatic elements from the poem are absent in the illustra-

tion. The caption is: "Before him the church stood large and fair."
The poem continues:

"I have builded my tomb," said Esbern Snare.
And he closed his eyes the sight to hide,
When he heard a light step at his side:
"O Esbern Snare!" a sweet voice said.
"Would I might die now in thy stead!"
With a grasp by love and by fear made strong,
He held her fast, and he held her long;
With the beating heart of a bird afeard,
She hid her face in his flame-red beard.

Though the poem is set in Zealand, a Danish island between
Jutland and Sweden, Esbern and Helva have the familiar Woodbury
"foreign" look of a young Dutch couple, she in white Dutch bonnet
and apron, he in trousers and loose shirt, both in wooden clogs. They
are not embracing "fast" and "long" as in the poem, but merely stand-
ing side by side, with a nearby third figure not mentioned in this scene
in the poem, but probably the baron, not the troll. Helva's little heart
may be beating like a "bird afeard," but she is not hiding her face in his
flame-red beard—indeed, in the illustration Esbern appears to be
clean-shaven. The church, as proper for one built by a troll, is a large,
impressive cathedral of some unspecified denomination, but the odd
and interesting thing is that it is standing in the middle of a typical
Woodbury landscape, no other buildings near, but with low hills
rolling like ocean waves, dark and light veins in the rock—no trolls, no
elves, no magic hammers, but three ordinary Dutch people gazing at a
combination of Notre-Dame in Paris and St. Mark's in Venice, magical-
ly plunked down among the rocks near Woodbury's Ogunquit studio.
Woodbury illustrations, then, move in the opposite direction of those
of, for instance, his near contemporary Maxfield Parrish. Where
Parrish would turn even the most ordinary subject into something
marvelous and magical, Woodbury turns the potentially exotic subject
into something ordinary and familiar, something remembered from
personal experience.

This approach is apparent also in the war posters that Woodbury
did in 1918. Titled "Liberty Bonds Guarantee Protection for Hospital
Ships" and "Liberty Bonds Guarantee the Safety of the Sea."[2] These
posters feature extraordinary, wartime events—in one, the sinking of a

hospital ship by a submarine—but the seas are familiar Woodbury seas in color, motion, and light. Though certainly the posters are examples of art in the service of patriotism and are intended to communicate a purpose beyond aesthetic pleasure, they nevertheless remain significant works of art, depicting the elemental power of the sea as well as the military might of nations. In these pictures the images of action and counteraction in water and foam balance and reinforce the images of man-made smoke and steel. These are genuine Woodbury seascapes.

Woodbury's illustrations and posters were not simply commercial undertakings. He illustrated books and painted posters for causes that clearly mattered to him personally. *Deephaven* and *The Tory Lover* were books by his wife's friend and neighbor Sarah Orne Jewett and are set in the seacoast area of Maine and New Hampshire that he knew so well and in which he had chosen to live. The Whittier poems that he illustrated were for the most part the ones set in places that he had lived in or near or had often visited. The posters he contributed to the war effort were reflections of a very deep patriotism—his son David served in the Navy during the war and Charles said that he would not paint ordinary pictures again until the war was over.

As early as the 1890s he had taken an interest in poster art, but he completed only a few: "Trolley Stops on a Bay State Triangle," "The Charity Ball," and "The May Century." As Sinclair Hitchings writes: "These and other designs by him are among the strongest in a memorable outpouring of posters by many American artists."[3] The posters, particularly "The May Century," again reveal a personal, not just commercial, interest in the assignment: Our recent M.I.T. engineering graduate shows a startled young man flying in a box kite, illustrating the article "Scientific Kite-Flying Described by Three Experts." And later in his career, he would not hesitate to lend his talent to mundane occasional or illustrative works for local good causes, including theater posters advertising a play by David and a painting of the traditional comic and tragic masks for the Ogunquit Playhouse.

But probably the most characteristically "Woodburian" of his illustrations were the drawings published after his death to accompany Willard L. Sperry's *Summer Yesterdays in Maine*. A former dean of Harvard Divinity School, Sperry offers reminiscences of his childhood along the York County coast, observations filled with spirituality and charm, inspired, in the words of one reviewer, "by a filial devotion to the beauty and integrity of things seen... the most ordinary experiences

are the substance of the book, written, however, with a sensitiveness and charm which will delight the reader."

This was a perfect book for Woodbury to illustrate, a full collaboration between one philosopher with a brush and another with a pen revealing the spiritual depth inherent in the daily life of ordinary people along the Maine coast. Unlike the earlier illustrations for the Jewett and Whittier books, these are loose crayon drawings, similar to but more finished than the sketches that he produced by the hundreds on five-by-seven cards. True to his tenets, he does not focus on the facial details of people, but rather conveys a sense of figures doing something , even if only watching someone or something else while standing still. Appropriate for this book, what Woodbury celebrates in these drawings is not the stereotyped downeast eccentric, but normal people doing what they normally do whether at work or relaxing: carrying fish, sitting on rocks, reading, stretching in the sun, a man in city clothes and hat standing with his hands behind his back watching as men in overalls bend to gather clams. As in *Deephaven,* the illustrations are not merely of specific events in the book, but rather evocations of a vanishing way of life that Woodbury knew well from close personal observation.

Not an illustration but a work that shows Woodbury's eagerness to capture a specific moment in time just as it happened is the series he painted of the solar eclipse of August 31, 1932. In preparation he set up his paintbox and six pochades on the rocks outside his studio. As the eclipse progressed, between 2:30 and 4:30 that afternoon, Woodbury painted six views of the same landscape, recording not the waning and waxing of the sun itself, but the changing effects of light and shade on the surrounding rocks and water. Labels record the time each view depicts: "2:30. Before the Eclipse." "3:00 Half Hour before Totality." "3:30. Totality." "3:45. Quarter Hour After totality." "4:30. After the Eclipse." These studies were exhibited in the museum of the Adler Planetarium in Chicago with the central label: "A great artist's impressions of light and color changes during a solar eclipse. Paintings by Charles H. Woodbury made at Ogunquit, ME, during the eclipse of 31 August, 1932." A Chicago newspaper review written in 1935 compares Woodbury's studies to Monet's paintings of the same haystack under varying conditions of light. While finding Woodbury's works interesting, the reviewer would have preferred something more dramatic: "Mr. Woodbury, it seems, misses the drama of a total eclipse—a drama that drenches the landscape in unbelievable colors, hectic, highly melodramatic—colors that challenge and surpass the colors on the Great Salt Lake, Utah. Nobody with a palette more subdued than Vlaminck's can

possibly convey this melodrama of color... Mr. Woodbury is an 'academician' grave and subdued. It would take a frenzied rebel, a roaring 'fauve' to do justice to a total eclipse of the sun."[4]

To be sure, Woodbury was not a "fauve," and his color scheme would not satisfy a critic whose taste would not admit as "great" any palette less energetic than that of a Vlaminck or a van Gogh, but as a scientifically trained observer, Woodbury was as much interested in accuracy as in effect. As the artist's son later noted, Woodbury had discovered "that the moon's eclipse light reversed the usual light conditions of a sunny day, establishing that moonlight can be polarized. My father has used his remarkable eye-skill to prove that this was so—an observation unknown to painters of the phenomenon."[5] According to David, whose literary specialty was the history of science and technology, Woodbury had made a contribution to science in a work of art, something that only a few artists—Leonardo inevitably comes to mind—had done before.

VIII

'Pure Line'

Aform of art in which Woodbury was especially proficient, but for which he has attained little general recognition, is his work as an etcher. He began in 1882, at age eighteen, etching small views such as the beach at Gloucester and shrubs on a hillside, and then printing them "home-style" on the clothes wringer. By the end of his life, some of America's leading etchers, such as John Taylor Arms (1887-1953) and Arthur William Heintzelman (1890-1965),[1] were comparing his mature creations to those of Rembrandt and Whistler. Sinclair Hitchings discusses Woodbury's development: "In the 1880s he experimented with tone, both in concentration of lines to create dark areas on the print, and in wiping the plate to leave ink on the surface in chosen areas. The style he came to in the twentieth century was one of pure line with only the most subtle and sparing use of plate tone."[2]

The chief characteristic of Woodbury's line, whether etched or drawn, is what Woodbury called its "suggestive value," the ability of the line to indicate rather than fully describe a scene or activity. Consider, for example, the etching "Fog," (1926). Two fishermen are unloading their catch from a beached dory, while a third fisherman stands some distance away with his back to the other two. Twenty or more seagulls circle and swoop nearby. The dory is at the water's edge, and one of the fishermen is standing in the shallow water. No other clear line of demarcation is visible separating water, land, and air. Nothing would seem to be more difficult to convey by lines than fog—by its nature indefinite, shapeless, shifting, unmeasurable, unlinear. But Woodbury marvelously suggests the idea of fog by faint crosshatched lines. We cannot see the fog, but we sense it and somehow know that it is there. Woodbury ingeniously finds a way by line to suggest the absence of line, a paradoxical definition of the indefinite.

As Woodbury writes: "My general interest in line is for its suggestive value, as it conveys the thought of force or motion, and leads the

attention. I use it to indicate light and shade rather than to fully express it and prefer that it should not lose its identity as line except in the few places where complete description is necessary. The line is used for itself as sensation and not as imitation and has often the value of a graphic gesture. It is as abstract as a word and stands for a sensation as the word does for an object."[3]

Woodbury often does his best work in depicting subjects that might not appeal to other artists. He was one of the first of his generation to devote complete attention, both in paintings and in etchings, to the study of waves and waves alone in the middle of the sea. Many artists painted shore scenes with surf and rocks, or boats on the horizon, or marine sunsets or sunrises or moonlit ripples, but no other artist that we know of devoted so much attention with such successful results to studies of the interaction of oceanic forces independent of man, waves and swells far from land, the link to the human artist-observer not part of what is visible within the frame.

The etching "Mid-Ocean," (1924), is not simply an etched reproduction of the celebrated painting of 1894, but is rather an independent work intended to suggest, by lines alone and in a small six-by-nine inch format, sensations similar to those conveyed in the large oil painting of the same title. In the painting a lacy white foam, probably from the stern of a large ship, plays over light and dark green rolling seas, with blue and purple, nearly black, water in the distance and a dark mist rising from the surface of the sea on the right horizon. The combination of agitation in the foreground and a vast but regular pattern of waves and troughs in the distance creates a profound sense of natural forces in balanced opposition, a deep fluctuating equilibrium. The etching, on the other hand, suggests a sense of enormous forces thrusting upward from far below, a combination of heavy and light lines, weight and lightness, a fine spray blowing where the water can rise no further into the air.

The sense of elemental power, motion, and depth that Woodbury conveys in this etching by the use of lines alone is repeated in two other studies of open sea: "At Sea" and "Heavy Sea." John Taylor Arms discusses the three together as examples of "abstract suggestion" rather than "expression in light and shade." As he notes: "Each was drawn directly on the plate, without preliminary study of any kind and, in each, everything is subordinated to an impression of form and motion. Whoever studies these prints is insensitive indeed if he does not smell the salt air, feel the whip of the wind, and sense the

surge and power of mighty waves. Granted a knowledge of form alone, these waves would have been static and unconvincing without the added knowledge of the movement and change which produce their forms at any one instant. And neither structure nor movement could have been told in lines were not each individual one instinct with those elements." [4]

One of the reasons Woodbury often chose the ocean as a subject for his art is that it represented to him in pure, almost abstract form the elemental forces that govern all nature, including ourselves. As he wrote in *Painting and the Personal Equation*, "The ocean is the simplest thing we know, and the most permanent. It looks exactly the same today as it did in the beginning and will be the same as long as the world lasts. We can study its surface through passing forms, such as mountains or dunes, which obey the same forces in changing material. We have gravity and the push of the wind as moulding agents in either case. I speak of the ocean now, not so much as a subject for painting, but rather to demonstrate to you the necessity of seeking causes in your attempt to see results."[5]

One difference he notes between the European and American landscape is in the clearer American air, the touch of uncultivated rawness still apparent all over our land.

One of the characteristics of American landscape is that it has a virility that you do not find in Europe. The American people are full of life, and their natural expression is force. We are not slow in action and we are quick-minded. We go to extremes easily, but we are not soft, not dreamers. The art that will come from America will be virile, like our air, which has the clearness of crystal. It is not "atmosphere" but a medium just the same. We do not see bare Nature, but Nature covered with a medium of beauty. The air in Europe is thicker, and gives beautiful color effects, but I believe it is foreign to our temperaments. Our land has a touch of savagery, and we are to make good on our own lines. When we are in England, we have a sense of long cultivation; that everything has been made artificial; that there is nothing first-hand. But we are a new people making a new country and a new art; we are also made by the country and dominated by it. Here everything is elemental; the hills have great lines, for they were scored and moulded by the glacier as it made its way to the sea. The ocean, too, placid enough at times, is boundless force quietly held in check. Everything about us suggests elemental force; and unless we can show it in some way, we are clearly out-

"Low Tide." Collection of George and Patricia Young.

side our environment. ... Force through delicacy, and not through brutal-ity, and the question is, How may we express it?[6]

The sea exhibits in purest form that "boundless force quietly held in check" that for Woodbury also pervades the American landscape and defines the American character. Line, for Woodbury, is the visible mani-festation of force, the vector that underlies all life and motion. The line moves in one direction until it hits something—land hits water, water hits air,—and is deflected in another direction. Etching, composed strictly of line, becomes for Woodbury an artistic schematic of the forces that inform our world and our lives. The artist's line does not fully reproduce but merely suggests the form that the viewer's mind can then fill in. The line acts to stimulate our stored memories of appropri-ate experiences and sensations, so a work of art becomes not a total rep-resentation of an object in the world but an invitation for us to revisual-ize, to reexperience, and to complete what the work of art has started for us. As Woodbury writes: "Don't tell all that you know; some of it

might be impertinent; let the other fellow do a little guessing. What is too definitely limited is prevented from being bigger than its limits. Create an interest by painting toward a possibility; never take anything to the top-notch, because after that comes anti-climax; but promise something greater to happen next. Never touch your highest; show that you can go higher if you choose—but don't choose!"[7]

"Low Tide" (1926), is a perfect example of Woodbury's idea of doing more by doing less. There are no human figures in this scene, but lines of varying thickness suggest sand, water, rocks, wind, and birds, seagulls, more than a dozen of them—exactly how many we really can't say, but there are plenty of birds, more than enough, with many of them lighting at the edge of the water to swarm all over something, and many more flapping or gliding in to join the party. We can't quite see, and probably wouldn't want to see, just what the birds are swarming upon—a half-shredded fish, a dropped clamshell—whatever it is, we can't hear but we can imagine the cacophony of flapping and screeching. And more swooping wings are on their way! Dark lines close together suggest exposed ledges, but again, exactly how many ledges, how much rock is underwater and how much above water, whether the rock is bare or covered with seaweed—all these are left "to let the other fellow do a little guessing." The entire etching is essentially a series of roughly but never exactly parallel lines intersected by other roughly but never exactly parallel lines at a forty-five-degree angle. None of the lines is perfectly straight—most are at least bent, if not wavy. And though the angles tend toward forty-five degrees, probably none would measure that exactly. And each individual object is at least slightly different from all the similar objects in its category: Each cresting wave is at a slightly different stage of its crest, each rocky ledge has a slightly different slope, each bird is a bit different either in size or in darkness or in wing position or in flight angle from all the rest. This is a good illustration of one of Woodbury's favorite structural devices: the variation of detail in parallel forms, highlighting the differences in similar things.

John Taylor Arms, himself a major figure in the history of American printmaking, emphasizes the formal mastery underlying the deceptive simplicity in Woodbury's etchngs: "Here we have a technique which is among the most personal I know in contemporary etching. Often apparently summary and careless, his draftsmanship reveals a sure knowledge of form and an appreciation of the tremendous significance of linear beauty. He can etch the wind by the rightness of the lines by

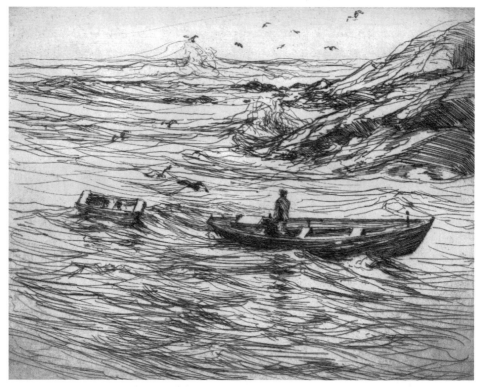

"Running In." Collection of George and Patricia Young.

which he portrays the bending trees; the volume of water by the weight of his line, and the swirl of the tide or the river's eddying current by its direction and sense of movement; he can etch rocks by lines partaking of their characteristics and forms; the nude body by those which caress and reveal its contours. All this is the very essence of suggestion, and suggestion is, by the inherent nature of the medium, the essence of etching, whether the print be created in terms of few lines or many."[8]

"Easterly Coming," chosen as one of the Fine Prints of the Year, 1926, shows three dories, each with a fisherman rowing hard for shore as the wind picks up, tossing foam over the submerged rock ledges. Here again, the principle at work is Woodbury's "significant line." So much is conveyed here—the strain of rowing, the pull of the sea, the gathering of the wind—all by parallel lines thickened, thinned, lengthened, shortened, and subtly angled. "Running In," winner of a 1931 prize in the exhibition of the Brooklyn Society, now the Society of American Etchers, depicts a similar subject: this time, one dory coming into the cove. But in this etching the fisherman is standing in the boat,

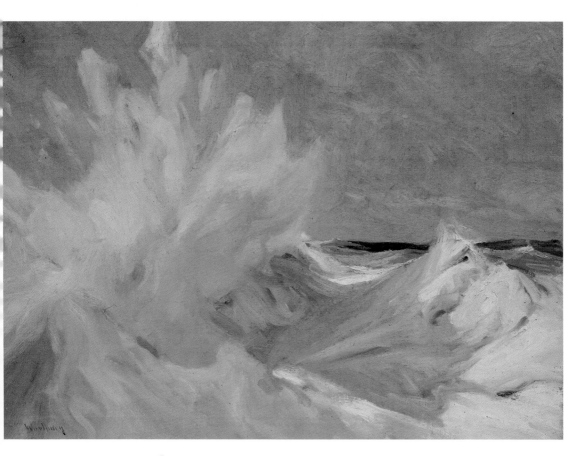

"'When an irresistible force meets up with an immovable object, what do you have?' 'Spray,' said the man as he clapped his hands in an upward motion thinking of the huge storm waves crashing on the rocky coast of Maine." Collection of Ruth R. Woodbury.

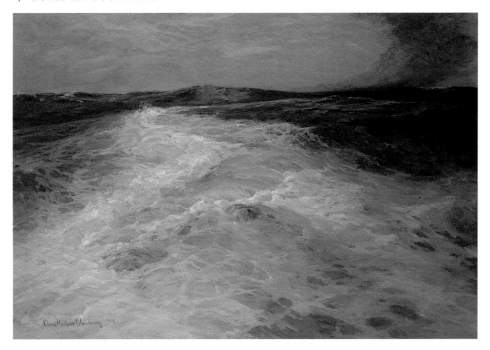

"*Mid-Ocean* may be said to be Woodbury's first serious effort to convey a personal impression of a great motive -- nothing less than the majesty and beauty of the sea.... the first of a series of works in which his chief purpose has been to give expression to the idea of force." Collection of the Berkshire Athenaeum.

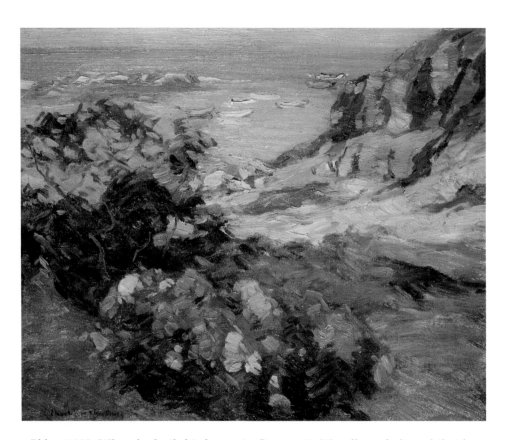

Phlox, 1933. When he built his house in Ogunquit, Woodbury believed that he had found one of the best views anywhere along the Maine coast. Visitors later agreed. This is the view from the front steps. Collection of Ruth R. Woodbury.

Challenge or *Red Motor Boat*. 1916. "The boat is bright red to attract the eye and hold it after the fashion of a crystal ball. It is a slight attempt at hypnosis." Private collection.

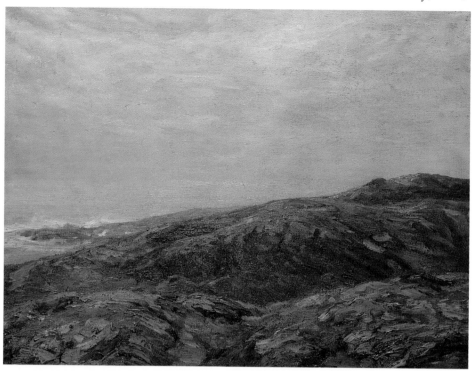

Hill Ranges (above) and *Green Wave*. Oceans like mountains and mountains like oceans. Whether painting land or sea, Woodbury's focus was usually on the gravitational forces that shaped the given element. MIT Museum Collections.

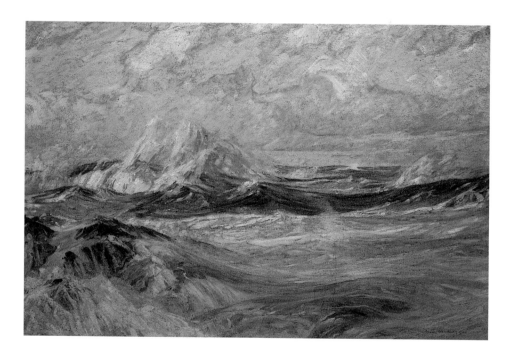

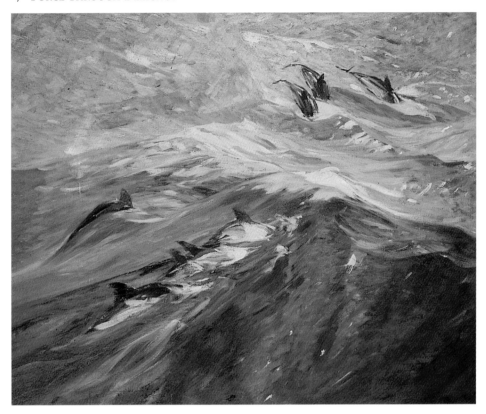

Panels of the Sea, # 4, Porpoises. "No man has ever more faithfully studied the sea than this painter. He, unconsciously, realizes the cause of each passing effect, and such is the training of brain, eye, and hand that he is able to record the fleeting impressions that go to make up the composite whole.... It is always the big things that interest him, the great primitive facts, and these he paints with the freedom of perfect comprehension: the small facts he uses only in the way of implying the big ones. Water is a very difficult thing to paint, because in painting it the obvious cannot be dealt with, only the abstract, and one feels that his sweeping technic – which carries a thrill with it as does the sight of the actual sea -- is eminently suited to the presentation of the aspect of the moody and mobile waters.... That he is an analyst in observation and a synthesist in production seems to explain the great interest and charm of Mr. Woodbury's style.... These recent productions show a departure from his former rule. Heretofore his work has depicted the sea in all its phases, but usually without the intrusion of the human element. Now he has introduced figures as 'accessories' (because that is what they are in the Great Plan of Things) into several of his sea pictures, and in others he has placed fish, schools of porpoise, etc...." MIT Museum Collections.

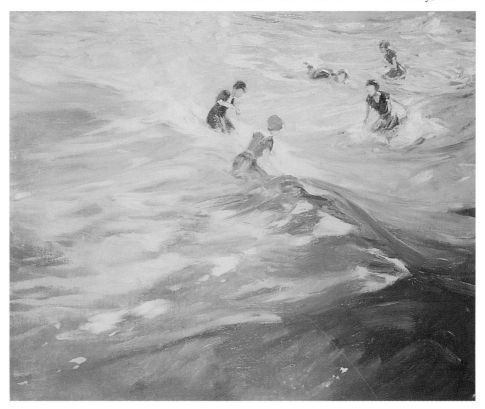

Panels of the Sea, # 7, Bathers. MIT Museum Collections.

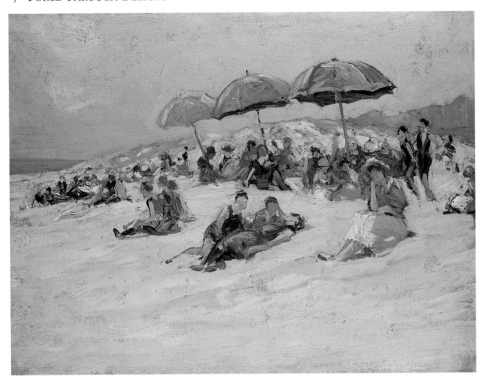

Three Umbrellas 1920, and *The Bath House, Ogunquit*, 1924; In Woodbury's beach paintings, the emphasis is on figures relaxed, doing little or nothing, enjoying themselves or the company of others in low-key activities. *Three Umbrellas* collection of Robert C. Vose III, and *Bath House, Ogunquit*, collection of Marcia L. and Abbot W. Vose.

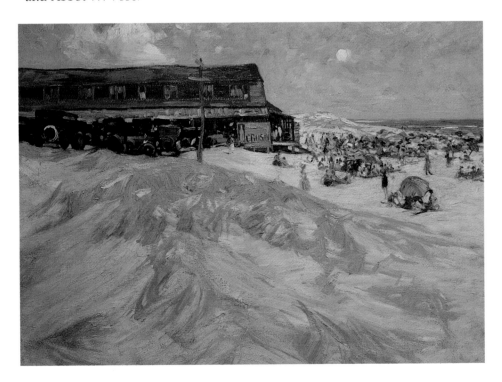

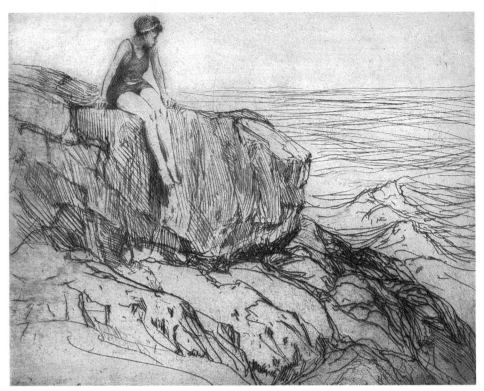

"Ledges." Collection of George and Patricia Young.

seagulls are flying, and the wind- tossed waves beyond the rocks are in contrast to the calmer waters entering the cove. Where "Easterly Coming" shows men straining against the natural elements of wind and water, "Running In" shows one of those other moments, just as real, when man can relax and let the natural forces take him where he wants to go.

Some of Woodbury's best etchings, in fact, show man not in those rare special moments of heroic struggle against the elements, but in the more common minutes or hours when he is resting, or enjoying some pleasant outdoor activity; the boat cruising in calm water, the road through the trees when no one is traveling on it; the hilltop with leaves stirred, not shaken, by a light breeze. "The Pilot" and "Pilot No. 3," similar views from the deck of a larger vessel down toward a small pilot boat trailing a dory, are, in John Taylor Arms's words, "characteristic interpretations of a subject dear to the artist's heart. . . . He who knows ships will welcome, too, the manner in which Woodbury's not only ride the sea but rest in it, with their hulls felt below as well as seen

above the surface. Observed with knowledge and drawn with a hand capable of suggesting their true forms from every angle, they are convincing: and it is this soundness of draftsmanship which is at the bottom of everything Woodbury does, as it is of all art worthy of the name."[9] In these prints the seas are calm, the clouds indicate fair weather, and the people in the boats are doing the work they do every day, busy but not agitated.

In "Ledges," a wonderful print that won the Noyes Award in 1933 as the best work in the exhibition of the Society of American Etchers, a girl in a bathing suit sits on a high ledge overlooking the sea. Where she sits might sometimes be a dangerous perch—every year in high stormy seas people are swept off low cliffs like this one—but not on this day. The potential for danger is suggested in the way the girl braces herself against the rock, in how she watches the waves below, and in her position seated well back from the edge and leaning just ever so slightly away from the water. The waves below show some chop, but basically the seas appear calm. She is enjoying the sun and fresh air, but she is not totally relaxed, not lying back with her eyes closed, as bathers are in some Woodbury etchings—it's a fine day, but the potential for change is hinted. The lines tell the story: On the left side of the image the lines depicting the girl and the rocks are mostly vertical, objects at rest, not in motion; the lines on the right depicting the water are horizontal. The static verticals in the foreground dominate, but the fluid horizontals in the background remind us that everything can change quickly.

"Sunshine and Shadow" shows two female nude bathers just off a rocky shore. One of the bathers is standing or kneeling in the water as the surf splashes over her, while the other leans back on a half-submerged ledge as the water flows in. The etching is a wonderful study in contrasts: light and shadow, water and rock, flesh and stone. As John Taylor Arms notes about this work: "[C]ontrast the coarse, apparently careless line-work of the rock on which the nearer figure rests with the ordered groupings that define the planes of that figure, and with the weaving, flowing lines of the water from which both seem to grow, and see how, in each case, the suggestion is tersely yet emphatically made." [10]

"On the Beach" is one of Woodbury's few crowd scenes, with fifty or more figures jammed into a seven-by-nine-inch plate. The day appears to be a clear, pleasant one in late spring or early summer. Many of the figures are dressed not in bathing clothes but in ordinary

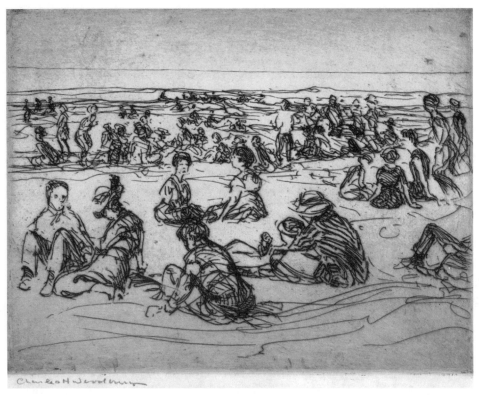

"On the Beach." Collection of George and Patricia Young.

street clothes: women in long dresses and hats, men in trousers, socks, and laced shoes. One figure near the water's edge seems to be shivering—perhaps she is not a Canadian or a native Mainer. Most of the figures farther out in the water appear to be children, while most on shore are grown-ups. Some are standing, others seated. They are reclining, talking, digging in the sand, leaning back, bending forward, but rather than focusing on one person or a specific activity, the emphasis is on indefiniteness, multiplicity, and activity. Many of the figures are simply blurs of motion, left to right or right to left, others are suggestions of heads or bodies planted here and there in the sand. One person is simply a knee and a hand—whether the rest of him is in a beach chair or reclined on a rock, we can't tell. A few of the figures have eyes and mouths, but only one or two have readable expressions. The ones in or near the water may have come on a planned day at the beach, but the ones in the foreground, higher up on the beach, farther from the water, the ones dressed in street clothes, look as if they may

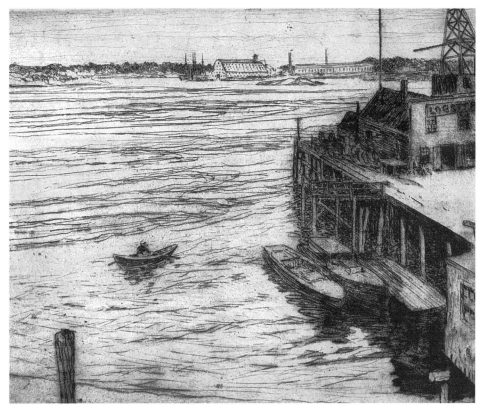

"Ebb Tide," one of the Portsmouth series. Collection of George and Patricia Young.

not have planned a beach day but came just because the weather was so fine that they couldn't stay away. On this day at the beach no story is fully told, but many are suggested. Nothing in the scene is very dramatic or climactic; everything suggests normal, ordinary life, activities that have been going on unnoticed before the artist sketched this moment and that will go on unnoticed after.

In addition to the beach and rocks near his Ogunquit studio, the Piscataqua River as it flows toward the sea between Kittery, Maine, and Portsmouth, New Hampshire, is a subject that Woodbury drew and etched many times in the twenties and thirties. The river currents are particularly strong at certain points there, and one theme that recurs in this series is the contrast between the swirling currents of the Piscataqua and the old brick buildings and docked ships along the Portsmouth waterfront. John Taylor Arms especially liked "Portsmouth," in which "the distant houses and the mounting hill to

the left, crowned by its churches, are thrown in with the dash of a brilliant sketch, yet there is not an unstudied fragment. In the middle distance come the flowing lines of the running tide against which the single tugboat—placed in exactly the right spot—is forcing its way; and in the foreground the remains of an old wharf and half-submerged hulk are etched with vital, powerful lines that furnish just the dark note needed as a base to support the whole composition. Over all a few delicate, tremulous, horizontal strokes suggest the tranquil sky of a summer day and a sense of aerial space and volume."[11] "Old Portsmouth," "The *Constitution*," "Fishing," and other etchings in the Portsmouth-Kittery series all play on the same theme: the moving river and the resisting or unmoving objects past or around which it flows.

In one particularly fine etching, "Captains," two old, heavy figures, probably former seamen, sit on a dock with their backs to the moving water. A dory tied to the dock has been pulled out into the swift current behind them, and farther in the distance the bridges and buildings of the town are visible. The river current moves in one direction, the trees bend slightly in the other. One of the old captains is looking directly at us, the other is staring down at the dock. Woodbury never loads his work with symbolism, but suggests here and elsewhere that his scenes convey more than a simple reproduction of the visible. Currents and countercurrents, light and shadow, motion and rest, vertical and horizontal lines all suggest a complex world of contrasting forces, visible and invisible, in harmony and balance.

Woodbury often applied his scientific and artistic abilities to the problem of how to show atmospheric conditions using lines alone. One of the most successful, in addition to "Fog" discussed above, is "The Ridge," a six-by-eleven-inch etching of a ragged line of thin trees on a ridge in a gusting wind. The top of the ridge rises one inch above the lower margin on the left edge of the plate to a height of just two inches at the right edge—the rest of the plate belongs to the wind and to the thin trees that are here merely tentative wispy projections of the land into the fierce dominion of the wind. A broken white birch trunk testifies to the power of the gusty currents. The idea of wind is suggested by diagonal hairlines mixed with swirls and light crosshatching. In addition to wind, a spitting rain could be pelting the top of the ridge. Here in pure form is the Woodbury sense of motion, the suggestion of turbulence at the point where two elements, here land and sky, come together. The trees, which reach both up into the sky and down into the land, are the visible indicators of the intuited turbulence.

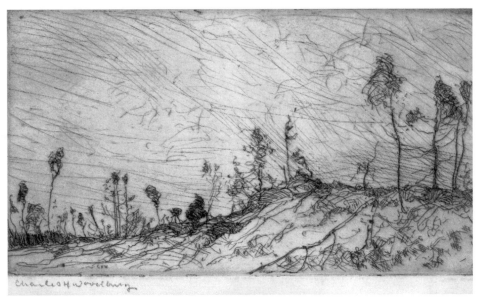

"The Ridge." Collection of George and Patricia Young.

Woodbury loved to travel, not only to Europe but also to the West Indies, where he cruised on a schooner almost every spring . He executed a series of views from onboard the cruise ship of the tropical mountains and harbors: "Mt. Pelee," "Mt. Pelee Smoking," "St. Thomas," "Blue Beard's Castle," "Domenica," "Tropical Port St. Lucia," "Nut Meg Island." What is interesting in this series is that he treats the elements of sea and land almost in a reversal of their usual aesthetic roles: The sea is flat, calm, and smooth, almost listless, while the land is deeply furrowed, rippled, all but heaving in waves and ravines. Here the jungle-carpeted mountains and the volcanic clouds that lift from them seem the dynamic elements in the compositions and the sea appears stable and untroubled. The focus of the Caribbean etchings is not so much on the exotic details of scenery as it is on the larger forces at work in nature, some similar to and others different from the forces he had observed along the North Atlantic shores. Here the mountains plunge more precipitously, the seas rock more gently, but the intersection of the elements of earth, sea, and sky remains the chief object of Woodbury's artistic attention.

Woodbury was a conservative, both as a man and as an artist, but his choice of subject matter was in no way dictated by sentimentalism or nostalgia. He drew people and objects that represented either a timeless or a vanishing way of life, to be sure, but he also loved to

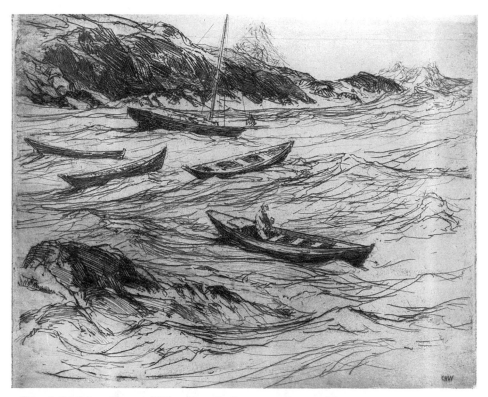

"Sea is Making," one of Woodbury's finest marine etchings.
MIT Museum collections.

draw airplanes, telephone poles, parking lots full of ice trucks and
Model T's, speedboats, young female nudes, dogs, cats, porpoises, and
elephants. His mastery of line is especially evident in his many studies
of the vast, saggy, wrinkled surfaces of pachyderms in motion: front
views, rear views, side views, and angles. His large aquatic mammals
are no less successful. As John Taylor Arms writes: "In the very beauti-
ful plate of 'Porpoises' the lines of the water and the fish were so vigor-
ously etched that, in the print, they stand as ridges of ink in high relief.
The sky, and the spray blown from a wave-crest at the left, are a net-
work of lighter, seemingly careless strokes. Concise as it is, every line,
in its weight, direction, and movement, supplements every other line
and is a vital note in a symphony of speed and power. There is no
attempt at literal imitation, yet the structure and life of each form is so
truly epitomized as to render exact definition superfluous."[12]

But of the nearly five hundred etchings he completed, if there is
a single one that seems to say "Woodbury" more than any other, it

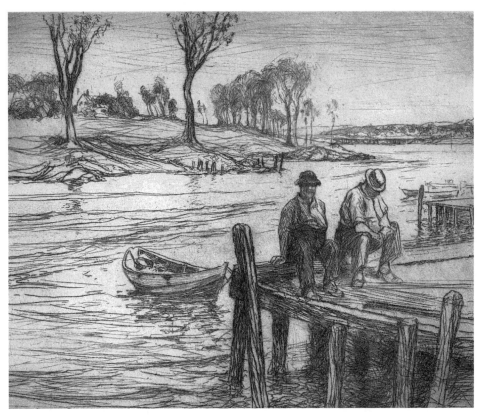

"Captains." Collection of George and Patricia Young.

might well be "Sea Is Making." Executed around 1925, this etching depicts five boats, one occupied by a fisherman, each rocking at a different angle in the choppy water. At the top of the plate a rocky headland descends into the water, with waves crashing over the lower end. Water also surrounds a half-submerged rock ledge in the lower foreground, and crests into a spray at the end of the headland. The swells and dips suggested here are enough to slightly churn the stomach of many an inland landlubber, but do not seem at all to faze the steady fisherman either standing or kneeling in the nearest rocking dory. For the sense of motion it conveys, "Sea Is Making" gets this author's vote as one of the uncelebrated miracles of twentieth-century American art.

IX

'A Slight Attempt at Hypnosis'

As good as it is, Woodbury's work as an etcher, as an artist of line, does not match his accomplishments in watercolor and oil. Even more than line, he considered color the primary ingredient of a painting, and in his books he devoted a great deal of attention to scientific descriptions of color and to the practical means of suggesting color on canvas and paper. One of his tips to art students was to apply to the canvas colors more vivid than those in nature. Natural colors viewed outdoors benefit from the sun, but colors on a painting hung indoors depend on weaker artificial light, so to communicate the same feeling of red or green indoors that the artist sees when painting outdoors, brighter pigments are required.

Woodbury's use of color is especially apparent in a work like *Challenge* or *Red Motor Boat* (he used both titles) which he both painted and etched. The sense of speed and motion through resisting water comes through in the etching, but until one sees the painting the idea that the boat is red may not occur to the viewer. What is important in the etching is that the boat is moving very rapidly through water—the action, that is, not the object. But in the painting the fact that the boat is red somehow changes everything. In the etching, the difference between the rock headland and the water is rendered by lines, primarily vertical for the rocks and horizontal for the water, but in the painting the differences in color give even more visual information than do the lines. Woodbury himself writes about this painting in *Painting and the Personal Equation*:

> If we were to paint a speeding motor boat, a photograph would be of no use except as it would furnish information as to the actual shape of the boat. We deliberately make our arrangements to seem spontaneous, which is, of course, part of the suggestion. . . . The boat is bright red to attract the eye and hold it after the fashion of a crystal

ball. It is a slight attempt at hypnosis. Having fixed the attention, we make the bow definite and leave out the stern, in a vague mixture of boat and foam, for with a moving object the eye goes to the advanced point and sees what follows but vaguely. The bow wave has a sharp rise and drops in a long curve which depends on the weight of the boat, the shape, the speed, or its acceleration. The man is poised with his weight thrown forward to offset the swift motion. The wake follows, triangular in plan, with the boat at the apex, spreading in accordance with the shape of the bow and the degree of speed. The ripples in the foreground are elongated, and tend to become parallel with the passing object. Here is a place where we deliberately diverge from the facts, for those ripples would seem elongated only if we were in the boat ourselves and swiftly passing them. This appeals to the memory of what we see as we move, and we transfer it to the boat as a thought of motion. the rocks in the background are sharp and definite, though general in their form and color, and through their stability, by contrast, give mobility to the boat. This is a nice balance, for they might become so stable as to attract attention to themselves. Still we have the red boat and it is an effort for the eye to leave it.[1]

Thus, for Woodbury, the purpose of the bright red is not to reproduce the color of the actual Ogunquit boat he used as a model, but to "hypnotize" the viewer, to fix the attention on a single object while the mind completes the suggested sense of motion.

Another of Woodbury's most dramatic uses of red is in *Phlox*, a view of the cove, as seen from the front steps of his home, with anchored dories bobbing in the water, the sun on the water and rocks, shadows near the viewer, and, in the middle of the darkest purple shadows, a cluster of pink and brilliant red phlox blossoms. To appreciate Woodbury's special skill as a colorist, we have only to think of the standard generic "Maine seascape" as painted by George McConnell, O.F. Baker, or any of the number of prolific but less talented artists who painted the sea beating on the rocks of Maine during Woodbury's day. The entire palette in these works usually consists of three basic colors: one for water, usually bluish green; another for the rocks, usually dark brown; and a third for the sky, usually bluish gray. Add a bit of white between the rocks and water for surf, and maybe a few spots of white in the sky for clouds, and you have a typical turn-of -the-century Maine seascape. In contrast, Woodbury employs dozens of shades of blue, green, pink, and gray to suggest water and sky, and a comparable num-

ber of shades of brown and yellow and purple for the rocks. The many tints of red, pink, gray, and white in the phlox add unexpected warmth and brightness to the most darkly colored part of the composition. The play of light and dark and the intermingling of various shades of the dominant colors make a Woodbury seascape as much an exercise in chromatic juxtaposition as a representation of an actual coastline.

In *Painting and the Personal Equation,* Woodbury tells the story of an observation, probably by his son David, that demonstrates the difference between a child's, an artist's, and an ordinary observer's sense of color: "As an illustration of clear childish sight I remember one late afternoon, as I was driving with a small boy of five, there was an old white horse in the near field which was in shadow, and beyond, a hill in the orange light. The boy said, 'Look at that blue horse.' It was a fact to the child, a relation to the artist, but to the majority of people it simply would not have been so. Experience teaches us that horses are not blue, and our eyes are likely to tell us only what we know."[2] To the child the horse was a blue horse, to the artist it was a horse that could appear blue in relation to the near shadows and far orange light, to the ordinary viewer the horse was white and the statement that it was blue could be at best a charming misperception. As an artist, Woodbury can use touches of blue pigment to suggest both the blue horse that the child sees and the white horse in shadow that the ordinary observer sees. In painting rocks, water, and phlox, Woodbury does not try to reproduce the colors that the ordinary viewer thinks he sees, but uses color combinations that make the familiar objects seem slightly strange, that enable us to see afresh in art the familiar things we may no longer pay attention to in nature. We may no longer notice the plants growing outside our window, but the phlox in *Phlox* simply cannot be ignored.

As early as 1891, Woodbury used vivid color not only to catch the viewer's attention but also to capture natural phenomena perhaps more apparent to his scientifically trained eye than to others. An article by an anonymous reviewer of an early Charles and Marcia Woodbury exhibit of Dutch views notes: "Among the unwonted scenes is the 'Sunday Afternoon,' a somewhat commonplace looking grove evidently for public entertainment, with uncompromising angular lines in wooden palings, and long slim trunks of thickly set trees; the whole picturesquely presented, but with a curiously strange feeling produced by the green of the trunks in the cool clear light; giving the impression that the trees themselves, after the Dutch mania for tidying everything up, have been painted green! But whoever has been in the low coun-

tries of northern Europe will recognize this effect as thoroughly natural and entirely veracious, coming as it does from the growth of green moss on the tree trunks and limbs caused by the damp and saturated atmosphere of that climate. It is remarkable that this effect has not been made pictorially familiar before. The reason doubtless is that the low tone in which Dutch painters have been accustomed to work has caused the mood of a scene to obscure its color, but Mr. Woodbury, painting in a higher key, brings it out and makes us recall it as something that has in actuality impressed us as forcibly as the picture here presents it."[3] Just as in some works Woodbury chooses to make the strange familiar, in others he chooses to make the familiar slightly strange. Here the artistic device of "making it strange" works not only to focus fresh attention on a familiar object but to point out features in nature previously unrecorded even by artists native to the scene.

In Woodbury's oil paintings, color is always an important element, but in his watercolors, especially the ones done after about 1900, color serves roughly the same function as line does in the etchings. The early watercolors, particularly the Dutch scenes, sometimes have the appearance of graphite drawings filled in with color. One watercolor that shows the direction his later works would take is Breaking Wave 1904.[4] Here broadly stroked bands of color define the separate elements of sky, sea, and sand. The boundary between water and land is indistinct, as if the moment captured is one in which, as a small wave just offshore breaks inward, the water nearest the viewer is receding outward, revealing patches of sand in the water and momentary pools of water in the sand. Using color alone, Woodbury is able to convey here that sense of double motion, simultaneously inward and outward, that we almost always perceive in nature as we walk along the beach, but almost never see in seascapes painted by any but the greatest artists.

As in etching, so in watercolor, both artists and art critics of the day regarded Woodbury as one of the leading masters. A 1933 review begins: "The dexterity with which Charles H. Woodbury inculcates atmosphere into his watercolor paintings is an important demonstration in the special exhibition now at the Corcoran Gallery of Art. This leading American water color artist depicts his mountains and seaside and rolling oceans with bold strokes and yet with a delicate restraint that sets them apart from most of the water color artists of today. He runs the entire gamut of technic, his bolder stronger work, suggesting oil rather than water colors as his medium, and his delicate tones suggestive of pastel work."[5]

One of several works that received special mention in the 1933 exhibit is The *Eruption of Mount Pelee, 1930*. Here, as always, Woodbury was interested in combining scientific knowledge and artistic talent to convey a realistic sense of the many forces active and in motion in a volcanic eruption. As the reviewer states, the overall effect is "colorfully vaporish rather than vivid in the presentation of this natural phenomenon." No ship or village or other creation of man is visible in this watercolor—only the forces of nature made visible as broadly brushed areas of delicate color representing sky, vapor, mountain, and water, all appearing to spill down from right to left. The gradations and mixtures of blues and greens, purples, pinks, mauves, tans, and the several nameless colors in between create a marvelous sense of intermingled primary elements—a glimpse of a natural phenomenon in totality rather than broken into separate pieces of air, water, and earth.

In our time the Woodbury paintings that seem to generate the most interest, at least at auction, are the beach scenes with figures and umbrellas. These often small, bright, quick sketches of figures in various stages of motion or repose convey a marvelous sense of simple pleasure. In a Woodbury beach scene, the skies are never entirely blue, the water is sometimes only a simple band of color, and no matter how many people are in the picture, no two are dressed or posed exactly alike. *Three Umbrellas* (1920) [6] is a good example. The nearest figure is a lady in a white skirt, cream colored hat, and orange blouse. She is sitting on the bare sand, chin on hand, looking out toward the sea, alone but not particularly lonely, probably just enjoying a brief sit at the beach before going back to the places and activities she is dressed for. Near her is a group of three recumbent women in bathing costumes: one on her back, another with her chin on her hand, and the third leaning on her elbow, but all three turned in toward one another as if in relaxed conversation instead of out toward the water. The next group of three are, in contrast, sitting up and looking out toward the water as if watching someone or something, as alert as the three next to them are relaxed. Behind the woman in the orange blouse, two girls in long bathing suits are running toward the water. Other figures, mostly adults, many looking even middle aged or older, are arranged here and there singly and in groups, sitting, leaning, bareheaded and with hats, knees up, legs out, talking, gazing, maybe playing cards, three groups under umbrellas, the rest under the open sky. There are probably three dozen figures in the painting, some identified only by the angle at which they stand out against the yellow sand or by the color of a towel or cap.

To sense more keenly what is specifically Woodburian about a Woodbury beach scene, we need only contrast a work like *Three Umbrellas* to , say, a typical Coney Island beach scene by Reginald Marsh. In Woodbury, we get a number of individuals or small groups of people, each separated from the other with space between; in Marsh, we really get a sense of masses and crowds, each individual or group overlapping the next with almost no empty space in between. In Woodbury what we notice are the colors the figures are wearing, whether caps or shirts or towels over the shoulder; in Marsh it is the bare flesh, male and female, minimally veiled by the merest hints of all but transparent clothing. In Woodbury, the emphasis is on figures relaxed, doing little or nothing, enjoying themselves or the company of others in low-key activities; in Marsh the focus is on the beach athletes, people chasing each other, grabbing, holding, climbing on each other. In Woodbury, the faces and physiques, sometimes even the genders, are indistinct—we see shapes that we know are human but the details are blurred; in Marsh we see very well-defined bodies, muscular males, buxom females, fat, thin, old, young, usually not simply revealing but deliberately displaying as much of themselves as possible. In Woodbury, people are sitting up or stretched out, at rest or in motion, but in whatever they are doing or not doing they are natural, comfortable, unposed; in Marsh, most of the figures—even those at rest—seem to be posturing, straining, aware of or trying to create an audience.

The Bath House, Ogunquit (1924)[7] could well be Woodbury's all-time champion Ogunquit beach painting. Dunes (miniature mountains), dune grass, ocean, waves, sky, clouds, people in bathing costume, umbrellas, a possible dog or two, automobiles, a telephone pole, an old wooden beach house, an Orange Crush truck—nearly everything Woodbury loved to paint, except rocks and boats, is in this work. On the left side of the canvas we have a crowd of mostly Model T automobiles, each parked at a slightly different angle from all others, most but not all of them black; on the right side of the canvas we have the crowd of people , also moving or resting at all different angles, to whom the vehicles belong. The Orange Crush truck is set right in the middle of the canvas, part in the vehicle half and part in the people half, a drink-serving bridge between the realms of the mechanical and the human. The view of land extends several miles, from the nearest dune, which is probably close to the Ogunquit River, to the distant stretch of sand, probably Kennebunk Beach, just at the edge of the horizon. The perspective is set so that nearly the entire lower half of

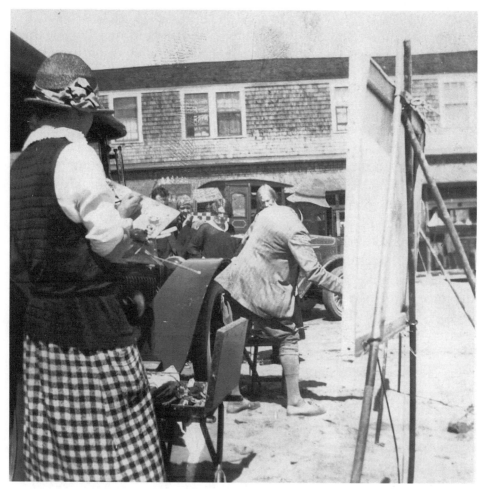

The artist painting *The Bath House*, Ogunquit, 1924.

the painting depicts dune and dune grass, the top quarter is sky, bro-
ken on the left by the long brown beach house, and all the signs of
active humanity, the people and their cars, are contained within a fair-
ly small horizontal band through the upper middle of the canvas. Here
again, as so often in Woodbury, the human world is an important part,
but not the only or even necessarily the largest part of the overall pic-
ture of nature.

In a photograph of Woodbury working on this very painting,[8] we
see an actual beach quite different from the one in the painting. In the
photograph, people and umbrellas are spread out all along the sandy
expanse instead of concentrated in a small band, and the dune

Woodbury is standing on is lower, with clumps of grass spikes sticking up instead of the smooth green waves in the painting. Rather than reproducing the scene as photographed, Woodbury puts people and their things in a prominent but limited area, a slightly depressed stretch of flatter sand between a large dune in the foreground and another large dune on the other side of the bathhouse, people not straining to dominate but at ease within the larger circles of nature.

In her fine essay on Woodbury in *Earth, Sea, and Sky*, Erica E. Hirshler compares Woodbury's treatment of the human figure with that of Winslow Homer: "Homer used the sea to express his ultimate theme, the relationship of nature to man. Woodbury too was fascinated with the power and strength of the ocean, but for him the ultimate goal was aesthetic, the rendition of three dimensional motion upon a flat canvas. For Woodbury, the figure is almost incidental, appearing either as a decorative motif or not at all. Never does one see the struggle of man against the force of the natural world that characterizes most of Homer's paintings."[9] As she further notes, the closest Woodbury comes to Homer's treatment of man and the sea is probably in the 1910 painting, *Lost Fisherman*, (the same painting is sometimes called *Winter Surf.*) Here we see a group of figures standing by a small fisherman's shack, looking out to sea. The figures and the shack occupy only a small triangular area at the middle left edge of the painting. Before them stretch a heavy winter sea with white rolling waves, a leaden sky, and, to the side and behind them, rocks covered with ice and snow. The figures form a small dark island in a large, cold green, and gray field of land, sea, and sky. As Hirshler writes, this painting is "an unusual example of Woodbury's treatment of a Homeresque theme. Yet even here the figures are small scale and decorative, showing none of the physical strength or heroic stance of Homer's statuesque fishermen and women. Woodbury instead emphasizes the sensuous curves of icy green and blue water." [10]

Unheroic, unromantic, Woodbury's painting of a village tragedy achieves its poignancy through understatement and detachment. What really can be said about the loss of a fisherman at sea? Woodbury doesn't try to tell a story of either hope or vain struggle against the odds, dramatic grief or consolation, but just shows a small group of people standing at the shore looking out toward a cold indifferent sea, one figure, probably a woman, returning back up the path toward the viewer. Woodbury raises no question and offers no answer here, but simply shows a relationship, sometimes harmonious but this time tragic, between man and something larger than man.

X

'Such a Green as No Lapidary Ever Could Match'

Although the small beach-and-umbrella scenes are more popular today, Woodbury, in a 1939 interview,[1] still considered *Mid-Ocean* (1894) to be his greatest picture. As an 1895 review in the *Boston Transcript* observed: "For those who have seen this sight from the stern of a steamship, who have remarked its extraordinary beauty of color, its wonderful action, and who have carried the memory of it faithfully in their minds, Woodbury's painting will be a splendid reminder of a splendid scene. It will bring back not only the sensations of the visual nerves, but also the accompanying and associated sensations of the other senses—those sounds of weltering, seething, hissing and whispering waters in wild liquid torment fleeing from the screw, churned into a tracery of foam beyond the thought of lace makers, underlaid with such a green as no lapidary ever could match, and shading off into a blue and purple so deep and intense that it astonishes and enchants the observer; and all those feelings of the exultant seaworthy passenger who clutches the rail and holds his breath while the ship sweeps down the long sloping slide of a monstrous Atlantic billow, leaving its wake zigzagging down that liquid mountain side for one glorious moment, only to rise slowly to the crest of another wave. . . ."[2]

To appreciate the impact that *Mid-Ocean* had on the viewers of the day, we need only remember the marine paintings then—and perhaps now—most familiar. One type focuses on ships: the kind of ship, sail or steam, the flags it flies, the ports it is entering or leaving, the rigging, the ship's name—all these details are important, while the water, even if painted in a competent manner, is not the major focus. Though good artists of many nationalities painted marine pictures of this nature, the name that most quickly springs to mind is Antonio Jacobsen (1850-1921). The treatment of water in a Jacobsen painting is fairly consistent, and late in his career tends to be perfunctory: longer,

71

deeper, bluer, fewer waves before 1900, especially when the ship is in the open sea; shorter, shallower, greener, and more numerous waves after 1900, especially if the ship is nearer port. The water in the larger, earlier ship paintings (known in the trade as the "good Jakes") is usually more carefully handled, and often shows realistically the effects of wind, ship motion, light and shadow, translucence and opacity. But the smaller, later paintings ("standard Jakes" or even "poor Jakes") seem always to show the same parallel wave patterns, the same colors, the same level of tops and troughs, so that the only significant variables from painting to painting become the name, number, and kind of ships. Other artists who painted works of this type, many of them better than Jacobsen, include Thomas Buttersworth (1768-1842), James Buttersworth (1817-1894), James Bard (1815-1897), Antoine Roux (1765-1835) and others in that large Marseilles family of marine artists, and Montague Dawson (1895-1973). But no matter how well they could paint water, these artists used waves and foam, choppy or calm, primarily as the background for the main subject—ships, what they are, where they are, and what they are doing.

Another familiar kind of marine painting focuses on action, whether dramatic or pedestrian, that happens to take place at sea: with battles, shipwrecks, rescues, storms and conflagrations on the one extreme, and coal deliveries, fishing , channel traffic, and anchorage on the other. One thinks of Turner's *Slave Ship*, Gericault's *Raft of the "Medusa,"* Vernet's *Seascape: the Storm*, the calm lagoon scenes of Edward William Cook, and any number of other favorite examples, in which the water is a dominant factor in an event or setting and is important chiefly for what it adds to the significance of that event or setting. The painted waves, for instance, in a painting such as Thomas Birch's *The "Wasp" and the "Frolic"* in the Karolik Collection of the Museum of Fine Arts, Boston, convey a marvelous sense of rocking, but the intent is to heighten the feeling of danger and conflict in the naval battle between the ships rather than to direct all attention to the water's tremendous beauty and force.

Several artists in the generation before Woodbury's , particularly those associated with the Luminist movement (1850-1875), produced works that still stand as American icons of the sea and shore: Robert Salmon (1775-1845), Fitz Hugh Lane (1804-1865), William Bradford (1823-1892), Alfred Thompson Bricher (1837-1908), William Trost Richards (1833-1905), and Francis Augustus Silva (1835-1886). Works by these artists differ widely in detail, but as interpreted by Barbara

Novak and the other contributers to the landmark publication *American Light*,[3] all share an emphasis on light and stillness, a tendency toward horizontality, a goal of surface smoothness and an absence of "stroke," an attempt to depict the eternal rather than the temporal, a longing for the sublime. The seascapes of Bricher and Richards[4] are particularly interesting to recall as contrasts to those of Woodbury. A typical Bricher seascape shows a roundish, deep green and brown headland sloping downward sometimes from the left and other times from the right, but in either case usually from a point about halfway to two-thirds up the vertical edge line of the canvas. The headland dips into the water at about the midpoint of the horizontal plane. The water is usually smooth as glass, except for a few low rippling waves near the shore, and the beach is sandy with perhaps a few round rocks draped with greenish brown seaweed. Sometimes one or a few small sails are visible on the horizon as a visual balance to the headland. Storms, a vertical format, tall rocks in the middle, choppy seas, and high rolling breakers do, of course, occur in his work, but in the painting that usually comes to mind when one hears "Bricher" the colors are cool, the rocks are on one side, and smooth water vanishes off the other edge of the canvas. This is Bricher's sublime, luminous vision of the timeless point at which land meets sea. Human figures are sometimes present, but they are usually small, often ladies with parasols, fully and finely dressed, as if for some occasion higher than a mere stroll by the water. In Bricher's seascapes, no one is doing work, getting muddy, swimming naked, or running toward the water. Even when the water and boats are moving, the effect is of a snapshot, movement frozen, the fraction of an instant when the motion is stopped just long enough to be recorded.

In addition to shore views like Bricher's with large rocks or headlands, William Trost Richards often painted the open sea, sometimes rolling, sometimes calm. In Richards we find a magical quality of light shining on and through the water, a sense of regularity and stately order even in the views of rough seas. Like Woodbury, Richards spent long hours studying the movements of the sea, measuring and counting waves, looking for patterns. Among American artists he is a master at stopping time, catching the wave at the instant of its highest point just before it begins to break, the moment that the poet Eliot would call "the still point of the turning world." At his best Richards turns a seascape into a moment of heightened awareness, a spiritual illumination. And it is against the background of this search for the single per-

fect moment of arrested movement and stopped time that Woodbury painted *Mid-Ocean*.

Most wave studies by Richards and other artists are painted from the shore, with at least a sliver of beach or one or two rocks to indicate that the world is not all water, that in addition to all that we see that is wet and rocking there is somewhere at least a firm and dry place to stand. Not so in *Mid-Ocean*. We can surmise from the serpentine trail of green and white foam that there is a ship and we are on it, but the world within the picture frame is strictly one of air and water—land, man, and man's creations are mere assumptions here, not objects visibly present. On the right horizon is a dark, swirling mass of air, but whether it is a smoke trail from the invisible ship's steampipe descending into the water or an ominous distant rising fog—this is left for the viewer to puzzle over. Though we assume that we are standing high on the stern of a large ship looking down at the water, the background waves rise so high on the canvas that they appear to be at or above eye level, while the deep troughs of the foreground make us feel that just as we are not above the tops, so we are likewise nowhere near the bottom. As a reviewer at the time noted: "The depth and strength and absolute power of the water in mid-ocean is so well conveyed to the mind of the onlooker that unconsciously he feels for some strong support, something 'to hold on to' for fear of being swept away into those limitless depths so well depicted."[5]

Though *Mid Ocean* may be the masterpiece it is not Woodbury's only pure study of water and waves. *Black Sea*, (1907), *At Sea—Violet Sky, The Green Wave*, (1920), *Sunken Ledges*, (1933) are notable variations, some in oil, some in watercolor, of the subject he returned to throughout his career. *Mid-Ocean* is painted in the earlier "brushless" style that Woodbury used before about 1900 for both seascapes and landscapes. In the later works, the "stroke" becomes more apparent: Single, long, roughly parallel brushstrokes of color, some broad, others thin, define the patterns of wave motion. One kind of wave study that he repeated many times is of a large, single, cone-shaped wave cresting while several smaller waves ripple nearby. Sometimes tipping toward the viewer's right, but more often toward the left, the oil, watercolor, pencil, and etched variations on the single breaking wave are among the subjects we think of as most "Woodburian."

Two older artists of Woodbury's time, Homer, whose work he was familiar with, and the great Russian marine painter Ivan Konstantinovich Aivazovskii (1817-1900),[6] whose work Woodbury may

never have known, had painted major "big wave" pictures before *Mid Ocean*. Through the 1880s, Homer painted both the sea by itself and the sea breaking against the rocks. The views he had near his Prout's Neck studio were similar to the ones Woodbury would later have some twenty miles down the coast at Ogunquit. A difference is that Homer characteristically chose to paint the ocean at its most dramatic moments: high surf driven by storm, huge waves rolling toward shore or crashing high against the rocks. Like Woodbury's work later, Homer's paintings are full of energy and motion, but where Homer tended to paint scenes that demonstrate that energy and motion at its peak, Woodbury tended to show the tremendous forces of nature present under even the most ordinary conditions. The sea in *Mid-Ocean* is not particularly stormy, the sky is gray but not lowering, there seems to be wind but not a real gale. *Mid-Ocean* shows us the power of nature when it is not trying to show its strength. As John Wilmerding notes in *A History of American Marine Painting:* "He worked with large, simple designs to express the expansive power of nature. These later works by Homer again suggest a parallel with Melville, who sought to give form to the forces of nature in his characters. About Melville, F.O. Matthiesen wrote, though he could equally have been writing of Homer, that he: 'developed his basic contrasts between land and sea, and between calm and storm, both for their own dramatic force, and as his most powerful means of projecting man's inner struggle.' This search to convey man's inner struggle with nature and his own inner conflicts motivated much of Homer's work in the decade following the Tynemouth experience."[7] The "inner struggle" so apparent in Homer's work is not what we sense in Woodbury, where a more detached objectivity views and depicts a delicate balance between opposing fields of tremendous energy.

According to David Woodbury, his father had discovered a special pattern to waves: "In every storm he studied the waves; as each seventh wave rolled in, it would be a block buster. These told him something his professors hadn't been able to teach him at M.I.T. Why was the seventh wave bigger? I never heard him answer, but he named one of his best watercolors for it."[8] In 1850, Aivazovskii counted the waves of the Black Sea—perhaps they were different from the ones at Ogunquit—and found a slightly different pattern. His *Ninth Wave* is to Woodbury's Seventh as Russia's 18,481-foot Elbrus is to Maine's 5,268-foot Mt. Katahdin. In this famous six-by-ten foot painting in the Russian Museum in St. Petersburg, a small band of survivors cling to the fallen mast of a sunken ship. A golden sun shines through the haze

and the survivors are gesturing as if to hail rescuers outside the picture's frame, but a wave of nightmarish dimensions is looming up to crash over them. And in an even larger painting of 1889, *The Wave* this work ten by fifteen feet and also in the Russian Museum, not just one ninth wave but an entire Himalayan range of them is sweeping over a capsizing boat loaded with armed figures while two or three other figures scramble to climb onto a floating mast. The waves here are so massive and extensive, and the ship and figures so small in proportion, that we might well imagine that only Noah could have seen more water around him than these unfortunate wretches.

But while the water and waves in Aivazovskii's great paintings convey even a greater sense of power and majesty than Woodbury's or Homer's, the emphasis is not on the power of nature so much as on the unsinkable toughness of man, the human ability to retain hope, the determination to scramble onto any floating thing despite the worst imaginable odds against survival. In these paintings the tiny figures balance and remain at least equal to the vast chaotic forces surrounding them.

In at least one painting, *Among the Waves* (1898), seven by twelve feet, in the I.K. Aivazovskii State Picture Gallery of Theodosia, we see water and sky only in a composition very similar to that in *Mid-Ocean.* Aivazovskii's painting is larger, darker, more turbulent, but is perhaps a simpler painting than Woodbury's. In Aivazovskii's painting all the rows of waves and the dark areas of smoke and cloud are arranged in horizontal parallel bands. The white highlights that mark the tops of waves also run parallel for the most part, with a few cross strokes at a forty-five- degree angle. Woodbury's painting shows water moving in more directions: The white and green wake of the ship snakes back along the vertical plane, while the larger waves beyond the churn of the screw line up parallel on the horizontal plane. In the sky the clouds, like the waves, spread horizontally; the smoke or rising fog cloud provides a vertical dimension in the sky to match and balance the wake in the water.

These are both great paintings, probably equally effective, but while Aivazovskii's tends to come right at you with an overwhelming sense of power and majesty, Woodbury's painting, with its lacy white verticals and deep green horizontals, calls again to mind one of his favorite aesthetic formulas: "force through delicacy, and not through brutality."

Woodbury's reputation as a marine artist was so well established during his lifetime that we tend to forget that he was also an accom-

plished landscape painter. One of his first paintings to win wide recognition, after*Mid-Ocean,* was *The Forest* , exhibited at the Boston Art Club in 1896. Works by Childe Hassam, Abbott Thayer, and Frank Benson won the prizes in this exhibition, but several reviewers thought that Woodbury's painting should have received one of the top awards. As one wrote: "*The Forest* is the most striking and powerful picture in the gallery. It is on a large canvas. Deep-rolling sand dunes, with a sparse growth of grass on their tops and brown moss on their sides, extend to the edge of a spruce forest of close even trunks. Within is darkness, unfathomable and mysterious as the ocean. Through the tops of the trees are glimpses of a dark blue sky. The sand heaps are broadly handled, but there is an almost symbolic evenness about the forest that makes the picture as a whole have not a little of mystery and power."

Another echoed: "*The Forest* by Charles Woodbury is the most remarkable landscape in the exhibition. It is a pity that the hanging committee should have flanked it by two pictures which are peculiarly adapted to injure its effect. The largeness and solemnity of the scene are suggested mainly through the simplification of its component parts. It is reduced to its essential terms, and stripped of all petty superfluities, so that the first and last impression it makes is of breadth, dignity, strength, and repose. This is the way nature strikes one: it is not so much the way that nature looks. Realism, so-called, or literalism, never attains to this grand air, never suggests so much of the unseen beyond. As Mr. Woodbury was able last winter to cause the imagination to rove over leagues of ocean, by the way in which he handled a comparitively small section of the sea's surface, so in *The Forest* he gives us an eloquent hint of mystery, of shadowy depths, and of vistas beyond our sight. Based upon observation of real things and real places, it is far from being a likeness of either, for it is filled with the magic atmosphere of the imagination. This causes it to seem the ... theatre for some great event; gives it an inexplicable cast of legendary significance; and clothes its dunes with a strange and sad poetry."[9]

I quote these reviews at length because they point out several features of *The Forest* that can be found in many of Woodbury's mature landscapes. First, he chooses for his favorite subjects scenes that initially might seem to have little intrinsic eye appeal: the wake of a ship in the middle of an empty ocean, the side of an obscure dune at the edge of a scrubby Dutch forest—this is not Yosemite or the Bay of Naples. Second, when painting dunes or mountains or small scrub hills, he shows the wave patterns, suggesting that the same fundamental har-

monic forces are at work beneath the surface of both land and water. Third, he leaves much unsaid and suggests much more than he depicts—for example, both edges of the canvas show only the beginning of an unfinished trajectory for the curve of the dunes in landscapes and the waves in seascapes, and tree branches and clouds are deliberately left incomplete at the edge of the picture plane, encouraging our imagination to complete the form that the brush has started. He prefers to work from real prototypes—actual locations on land or sea—but rather than produce a literal likeness cluttered by profusion of detail, he creates a spare archetypal image that is both recognizably specific and allusively universal.

Monadnock (1912) is one of Woodbury's most characteristic and best-known landscape paintings. The subject, Mt. Monadnock, is a 3,186-foot mountain standing by itself in southwest New Hampshire. It is not as high, nor as rugged, nor as spectacular a sight as several of the peaks in the White Mountains to the north and east. But Monadnock has special qualities that a scientist would appreciate: In geology, the term *monadnock,* coined after the mountain, refers to an isolated rock mass rising above a plain, a surviving remnant of a former highland. Because it is isolated and so much more of it is treeless rock that starts lower down the slope compared to other mountains of the same approximate elevation, Monadnock can be seen from a long distance and offers the day hiker splendid views after a relatively short uphill climb. Though not as famous a subject for paintings as Mt. Chocorua, Mt. Washington, and other views in the White Mountains, Monadnock has attracted its share of talented artists: Abbott Thayer (1849-1921), George DeForest Brush (1855-1941), Lilla Cabot Perry (1848-1933), and especially William Preston Phelps (1848-1923) all spent important periods of their careers in nearby Dublin, New Hampshire, and the mountain, whether as a background or as a main subject, occupies a significant place in their work. But none of them saw or painted it as Woodbury did: a succession of rising waves, each with its own blend of colors, from the thin trees at the bottom, through a wave of dark green scrub, through bare tan rock, through bluish rock and snow and ice, to the white caps of rock and snow at the peak, an undulant, oceanic mountain that reflects the same dynamics as the mountainous waves of the great seascapes.

As William Howe Downes, the most insightful of Woodbury's critics, wrote for the *Boston Transcript* in 1917:

Possibly there has never been a mountain picture surpassing this in the modeling of the surfaces, which is as thorough, subtle, and conscientious as if Monadnock were a living entity having its portrait painted. The grimness of such a rocky and snow-crested bulk in wintry conditions, spotted here and there with snow-patches, with ledges peeping forth, forests frowning darkly along the lower slopes, touches of rusty red suggesting the warmth of some ruddy growths, and one feather-light cloud shadow lying along the upper part of the height, this side of the summit, is softened by many a passage of beautiful color. The whole mountain is a sort of crazy-quilt patchwork of colors, seemingly chaotic, without order, a jumble of tones; yet in some ways the painter has pulled the things together and given it an organic unity. The suggestion of detail, as you see the canvas from across the room, is boundless and as generous as nature itself in this respect, but when you approach the picture you find nothing but big, apparently meaningless sweeps of the brush... Other men would have given special emphasis to other qualities in Monadnock: some would have made the mountain more urbane, more affable; others would have made it more romantic and picturesque; and others might have underscored its mystery, clothing it with a veil, as it were, of vagueness and wonder. Mr. Woodbury is a very forthright painter, who sees how things look, and sets down appearances without editing, though not without abridgment sometimes. He prefers, or better has the instinctive impulse, to arrive at suggestiveness and interestingness by the highway of straight veracity, leaving much of the business of imagination to his audience. In his 'Monadnock' he has made a notable contribution to the visible supply of mountain pictures."10

"Portsmouth." John Taylor Arms especially liked this etching, in which "there is not an unstudied fragment," and the tugboat is "placed exactly in the right place." Collection of George and Patricia Young.

XI

'Mr. Woodbury Has Let Himself Go'

Although Woodbury himself and many who wrote about him considered *Mid-Ocean* to be his greatest work, an equally compelling choice might be *Ten Panels of the Sea*, first exhibited in 1915 at the Guild of Boston Artists. Where in other major paintings he focuses on the tremendous power and majesty of the natural elements viewed by themselves, in these panels he fills the seas with animal and human life. Five, later four, panels show porpoises frolicking in the tropical waters of the Caribbean, the other five or four show bathers enjoying the summer sea at Ogunquit. In these panels, for the most part, sky and land are absent, the focus is on limitless ocean, with abundant life but without shore or horizon. As in his other works, the figures present do not dominate—indeed, as Erica Hirshler has pointed out, he eventually removed three figures from the lower foreground of one painting, demonstrating, as she says, that his interest in the figures was formal and for the sake of composition, not narrative. The removal of the three foreground figures in *Nine Swimmers* also serves to emphasize that what he is painting is not so much people at the beach as it is a great, vibrant element of water with its own life and movement and color including and containing that of many human swimmers. This view of the organic totality of ocean life is even more apparent in the tropical scenes, where the leaping porpoises share the colors and arcs of the leaping waves. William Howe Downes offers the best description of the works and their impact:

> . . . this is one of the events of the season. Mr. Woodbury has let himself go. His Ten Panels of the Sea form a veritable ocean symphony. It is his most lyrical performance. In this decorative and superbly rich series of marine paintings he sings with splendid abandon of the colorful and jocund seas, the rollicking and shining billows, the play of

sunlight on the wave and spray, the exuberant and graceful romping of the leaping and diving porpoises, and the joy of the bold swimmer; he exults in the beauty of the azure tropical waters and the wonderful sway of the ground-swells; he calls us to glory with him 'in the glad waters of the dark blue sea,' and to send our thoughts out 'as far as the breeze can bear, the billows foam.' These assuredly are his realms. . . . The most interesting are the Southern pieces, with their intensely blue tones, and the frolicking schools of fish, which are marvelous expressions of the joy of living. The entire conception of these decorative panels is highly original and spirited; they are free and gay and bold improvisations, giving a sublimated version of the holiday moods of the laughing ocean. It is poetry in paint, nothing else, and, while it is based on profound knowledge of the subject, it is anything but literal.[1]

A different reviewer in another Boston paper wrote:

No man has ever more faithfully studied the sea than this painter. He, unconsciously , realizes the cause of each passing effect, and such is the training of brain, eye, and hand that he is able to record the fleeting impressions that go to make up the composite whole . . . It is always the big things that interest him, the great primitive facts, and these he paints with the freedom of perfect comprehension: the small facts he uses only in the way of implying the big ones. Water is a very difficult thing to paint, because in painting it the obvious cannot be dealt with, only the abstract, and one feels that his sweeping technic—which carries a thrill with it as does the sight of the actual sea— is eminently suited to the presentation of the aspect of the moody and mobile waters . . . That he is an analyst in observation and a synthesist in production seems to explain the great interest and charm of Mr. Woodbury's style. . . . These recent productions show a departure from his former rule. Heretofore his work has depicted the sea in all its phases, but usually without the intrusion of the human element. Now he has introduced figures as 'accessories' (because that is what they are in the Great Plan of Things) into several of his sea pictures, and in others he has placed fish, schools of porpoise, etc. A work of this description is the big canvas of the incoming tide on a beach (one of the '10 panels of the sea') wherein a troupe of bathers is the centre of interest, although the big motif is the vibrant, flashing, scintillating mass of water. The color in this work is quite beyond description,

with the sea repeating the elusive blue of the unseen sky overhead and the shallow water close to the sands reflecting the golden depth overshot, as it were, by tints of melting turquoise, translucent greens, vague pinks and violets all bathed in flooding light, the salt-charged moisture of the air refracted by the sunlight and transmitted into the thousand delicate tones which, all together, make a veil of tender atmosphere.[2]

In these "decorative" panels, one of which was owned by John Singer Sargent,[3] Woodbury's sense of color, his ability to suggest movement, and his vision of life as a joyful energy that participates in a larger, harmonious universe of interacting force and mass find perhaps fuller expression than anywhere else in his work. Here, as nowhere else, Woodbury, to borrow Downes's phrase, "has let himself go." Here we see delight, but delight hard won: the poetry that rises from long practiced craft, the exuberance released from customary understatement, the dazzle of color following total mastery in black and white, a celebration of the sun after a long Maine winter, the extraordinary freedom that issues from habits of self-control, the love of play that comes from much hard work. These panels are Woodbury's "Hymn to Joy."

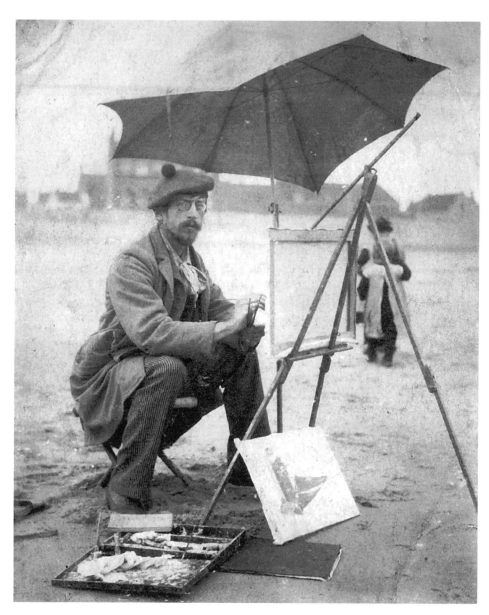

Woodbury at work. Collection of Ruth R. Woodbury

XII

"Then Paint As Though You Had Been Sent For"

Woodbury was that rarity, a first-rate artist who was also a highly influential teacher and a delightfully readable—sometimes even eloquent—writer. His letters, articles, books, and pedagogy reflect the same intellectual strength, the same love of order, and the same combinations of creativity and analysis that we see in his painting, and, indeed, in every facet of his life. The methodology that he developed in his Ogunquit school, run first by himself, then in collaboration with Elizabeth Ward Perkins, and finally with the assistance of the younger artist George Ross, was considered so effective that it was adopted by art schools across the country. Wherever he visited or taught, the "Woodbury Method" was welcomed by both innovators and conventionalists for its application of new teaching techniques to traditional forms of painting.

In a 1937 interview, we learn, for instance, that Woodbury and Mrs. Perkins "originated and developed the use of moving pictures in teaching drawing, and this has been taken up by other schools and teachers."[1] The idea was to teach art students, even raw beginners, to paint motion—"paint in verbs, not in nouns"—by having students try to draw objects that were moving across the screen. The interview continues: Woodbury "refuses to teach technique for itself. He would teach ideas first. 'Teach students how to handle themselves in order to paint, and incidentally, teach them to paint. Teach them to know what they want to paint, why they want to paint it, and whether it is worth while.'"[2] Art education, then, is first and foremost, an approach to life. Innovation and respect for convention go hand in hand. As we learn from the same inverview, "Mr. Woodbury helped to make over the curriculum in the art school at the Art Institute of Chicago in recent years. 'The young artists were in revolt against the old methods,' Mr. Woodbury explained. 'They wanted to do away with all old forms and

85

principles and have a radically new curriculum. And if we hadn't held them back they'd have done it. We finally convinced them, that would never do. A school cannot be made up of insurgents and accomplish any good. The young of today want to be geniuses without going through the work. Today I am proud of that school.'"

Woodbury's two published books, *Painting and the Personal Equation*, (1919) and *The Art of Seeing* (in collaboration with Elizabeth Ward Perkins) (1925), both grew out of Woodbury's work as a teacher. The first is based on six lectures that Woodbury gave in connection with the Ogunquit summer course in out-of-door painting. As he notes in the preface, "Although the immediate object was to instruct in painting, it is apparent that consideration of the psychological factor must be of the same importance in public appreciation as in technical performance. . . . There are as many realities as there are men." Technical instruction—for instance, how to catch the eye with a bright red—is only a small part of this book: Woodbury's main subject is the attitude, the practice of "seeing" that is required before anyone can paint pictures worth a viewer's attention.

Writing in 1919, a time when "revolution" in European art and society had already begun to make waves in America, even just across the cove in Ogunquit, Woodbury chose every opportunity to urge listeners not to overthrow convention just for the sake of rebellion. Great art exists within a context, and the idea that works of genius arise on their own, as pure inspiration free of convention, is sheer foolishness. In Woodbury's words: "I think that we shall soon draw the conclusion that there is very little chance of an important finish if the start itself is bad. There is no use in beginning with chaos. That affair was settled a long time ago and we live in an ordered world. It is useless to try to be even the original, primordial particle, you are much too old for the part, those simple old days have gone, and the most that you could do in that direction would be in the role of a civilized wreck. The sketch that you begin today has a long previous history in yourself. You do not start with the bare canvas; the picture is finished in you and to make it visible is the last step. It is not always a simple step to take and its evil name is technique. The easiest way is the academic, the manner of established respectability. Do not be afraid of it, for it is not necessarily reactionary. It means that best ways have been found to express a general line of thought. These ways may be adaptable enough to meet new conditions, but in any event the convention lies in the thought rather than in the technical method."[3]

Woodbury understood clearly that today's most radical innovations may become tomorrow's academic conventions. "All methods are bound to become academic," he wrote, " provided they are backed by a thought of sufficient importance to last a considerable time. . . . Think of the academic as a link in the chain that connects us with the first artist. If we add enough to the present store of knowledge, we shall be academic to those who come after. My thought is that we grow from the past."[4]

Even, or perhaps especially, in Woodbury's day, words such as "academic" and "conventional" carried such negative connotations that he had to go to great lengths to assure "creative" art students that it was all right for them to follow established procedures. "A thoroughly conventional training need hold only the man who was born to follow, and it gives the better man the right to diverge," he told them. " I do not have much faith in the spontaneity of genius. A genius probably has the power of acquiring essentials in an extremely short time when it would take a century for another to do so. But the essentials are the same in either case. It does not appear likely that any one can omit the training and start ready-made, though at the present time that seems to be considered possible. As for radical changes and discoveries that would sweep away all that has gone before, they will come when man himself changes. If we suddenly were to acquire the habit of going on all fours, I should expect the artist's point of view to be altered accordingly. Art is exactly where man is and develops with him."[5]

Woodbury's practical advice is often as judicious and witty as his philosophical maxims. The painting of rocks in a seascape, for instance, might seem a simple thing, but over the years Woodbury had observed something unusual about the rocks produced by his art students: "There is an ever-recurring miracle that happens year by year, for which Nature is in no way responsible. Why do class rocks float? There is no discredit to the painter, for they seem to do it by their own volition. Do not forget that when a wave meets a rock it is more like a fight than a party. And even if there is no assault, we have a line traced by a horizontal moving liquid on a vertical solid. It is force meeting resistance . . . When a wave breaks on a rock and there is a smother of foam, the eye finds it most difficult to follow the line. If you try to do so, you will assemble a number of facts that have happened at various times and together form a wave that is possible only in paint and quite beyond the range of the ocean. Stop to consider with what you are dealing; nothing is happening by chance. Every drop of that water is

obedient to the force that compels it. What a travesty to make your wave burst into absorbent cotton!"[6]

In addition to allowing their rocks to float, Woodbury's students often included light from several times of day in what was supposed to be an impression of one place at one moment. A rock might look red when seen in a certain light, brown when viewed in another, and not only the rock but also the objects surrounding it change color with the shifts in light. The mistake is not in painting the rock red, but in painting sand, water, seaweeds, sky, and clouds not as they appeared when the rock was red but as they appeared when it was brown or black. "I often find pupils who work patiently from nine till one," Woodbury said, "beginning with the sky and ending with the foreground, oblivious to the fact that they have recorded the changes of an entire afternoon. Consistency first."[7] The important task, Woodbury says, is to get the colors right first, not worrying about drawing finished details. Sketch the important masses and their colors as they appear at this moment, then check—if they are wrong, this is the easiest time to correct them: "You do not have to repaint a tone that is slightly wrong, but add to it the element that is missing. Put on the color in any way you choose, but choose the quickest way always. Scrub it on as if you were painting a fence or washing a boy's face. . . . Then paint as though you had been sent for. You cannot afford to lose a second anywhere—not a second. After the first five minutes you should feel a glow of satisfaction in the thought that whatever Nature might do in the way of changes, you have nailed that effect."[8]

Reviews of Woodbury's book were mixed. The poet Amy Lowell, writing for the *New York Times* ,[9] found the book "astonishing" and saw many valuable passages in it, but considered the general tone too arrogant, the opinions stated too abruptly, and the attitude toward modernism, of which Lowell was an ardent proponent, too unsympathetic. An even more negative review, in the *New Republic*,[10] finds Woodbury too pleased with himself, too facetious, too naive, shallow, and flattering in his opinions. The reviewer, identified only by the initials M.H., stands, much like Amy Lowell, obviously on a side opposite Woodbury's in cultural ideology, objecting particularly to the artist's lack of enthusiasm for the work of futurists and primitives.

But the book was also reviewed by writers with no personal or cultural agenda to advance, writers more interested in what Woodbury had to say than in how best to deflate his positions. Glen Mullin, writing for *The Nation*,[11] begins with a problem that any sympathetic com-

mentator, including this one, can understand: "In discussing a book so rich in aphorisms as this one of Mr. Woodbury's, the reviewer is put at hard labor to keep his quotations from it within manageable limits. Mr. Woodbury presents old principles with such freshness, he is gnomic with such a wealth of paradox and whimsy, that passage after passage deserves to be quoted." Mullin appreciates the originality, complexity, usefulness, and fairness of Woodbury's writings, correctly noting the stress that Woodbury places on the psychological dimension of painting and comparing Woodbury's insights to those of Bertrand Russell. G.W. Harris and several other reviewers identified only by initials also found much in the book to recommend to readers of various newspapers and magazines in 1920. One of them, in a long review full of quotations, describes the book as "delightful and stimulating," full of "tang and wisdom." Another reviewer confesses from the beginning that he is "quite at a loss how to proceed. It baffles any conscientious attempt at condensation. Any Occidental presentation of ideas we will undertake confidently; but this—it is Oriental. Every page teems with thoughts, each one a distinct entity, each one furnishing food for contemplation, and yet each necessary to the rounding out of the whole. .. As well attempt a digest of *The Rubiyat* or a synopsis of the Sermon on the Mount."[12] And G.W. Harris writes: "The old admonition to painters to mix their colors 'with brains' receives fresh utterance, or rather restatement in the new terms of the scientific spirit of to-day, in this interesting and stimulating book by one of the most brilliant of contemporary painters, who writes almost as vividly as he paints."[13]

Woodbury's second book, *The Art of Seeing* , subtitled "Mental Training Through Drawing," is more like a teacher's manual for the "Course in Observation" than a compendium of epigrammatic philosophy, anecdote, and advice. It contains an entire curriculum for "seeing," with specific instructions, examples, and exercises appropriate for students from kindergarten age through adult. The purpose of this instruction is not simply to train future artists—though that may be one result—but rather to enrich life for everyone by increasing the powers of memory, imagination, and perception: art as mental training, every bit as intellectually rigorous, personally useful, and socially beneficial as reading, writing, and arithmetic. Woodbury sets forth the proposition that communication through drawing , by virtue of its universal ability to be understood, may in an international, multicultural future become as important as communication through spoken or written language. He further suggests that drawing may be a more

accurate test of intelligence than oral or written effort because drawing requires a clear conception before it can be executed and "confusion betrays itself more directly in the line than through words."[14] Through his method of teaching "seeing," Woodbury's ultimate goal is to contribute to a society of people able to "see life directly and without preconceived ideas. . . . When a person has begun to look without fear and to make his personal choice, he is set in a direction to develop his full resources."[15]

In addition to these published books, Woodbury left an uncompleted typescript titled "Disreputable Remarks by Charles H. Woodbury, The Epigrammar 1928 to 1940." Not many of these remarks are actually disreputable, but some are better formulated than others. Among the most quotable are:

"When a man follows someone else he usually follows the other's weakest point."

"When I am painting with intent purpose I could not stop to die."

"An artist can take any subject and make it what he is."

"Paint it the way it seems, not the way it looks."

"A Boston dinner party is a local anesthetic. A New York one, a synthetic stimulant."

"The machine is the materialized relation between work and humanity."

"Motion is a time relation between masses."

"To be without humor is to be without measure."

"I am not a sculptor, because I cannot imagine myself perpetually symbolizing Truth, Beauty, and Justice in the form of a woman."

"Up to forty we may run along on our emotions. After that a mind is a great convenience."

"If drawing does not imitate, it may say something. If it imitates it counterfeits."

"An ancestor is a man who was better than his descendants. Otherwise why mention him."

"Marin takes the familiar objective and makes it so definitely subjective that people when seeing the picture are forced to think in subjective terms. They gain power through the use of their own powers of discovery."

"Style comes from purpose and in these pictures there is no purpose but style!"

"Most of the world has no work but forced labor."

"Bulk can be imitated, but motion must be expressed."

"Perspective has always been a convenience and a luxury—now it is a necessity, even a matter of life and death. The changing perspective of the approaching motor tells us if we may pass our neighbor ahead. We judge its direction by its size, and its speed by the rate of change in size, and if we make a poor guess there is an end of us. The dimension of illusion must be taken seriously."

"Paint in verbs, not in nouns."

"You can convey information, but you must share emotion."

"Burn your candle at both ends—the only way to make both ends meet."

"Boston has been cultivated for so long that it does need a little fertilizer."

"I paint conditions and not things."

"To imitate is skilled mechanics, to indicate and suggest is art."

"There is no 'right' way. The right way is your personal way. There are good and bad ways, but not right and wrong."

"The people who lose their minds are often those who never had them."

"The human unit is the cosmic molecule."

"Camembert cheese tastes as nothing ought to smell."

"Should the future be restricted to the perfected past? That is what the conservative would like."

"All people are created free and superior, especially the young."

Woodbury with self-portrait, 1937. Collection of Ruth R. Woodbury.

XIII

'A Great Artist, A Great American, and One of the Finest and Truest Friends I Ever Had'

—JOHN TAYLOR ARMS

Woodbury continued working as both artist and teacher until the very end of his life. According to Elizabeth Ward Perkins, he had taught an unusually successful class during the summer of 1939, then met that fall with George Evans of Toledo University to plan a new book, and contributed a group of watercolors to an exhibition at the Museum of Fine Arts in Boston: "Half Century of New England Watercolors." Early in 1940 he returned to Boston, where he had an apartment and studio at 132 Riverway, although he sometimes stayed in a room at Mrs. Perkins's House in the Wood in Jamaica Plain. He held his usual class on the morning of Saturday, January 22, after which he worked on a new watercolor and went over plans for an exhibition at the Guild of Boston Artists. He died suddenly the next day, Sunday, January 23, at the home of Mrs. Perkins. Among the many tributes by fellow artists, a telegram to Mrs. Perkins from John Taylor Arms read: "Deeply shocked by the passing of a great artist, a great American, and one of the finest and truest friends I ever had. I send my sincerest sympathy."

At the time of his death, Woodbury was regarded as one of the greatest American artists of the twentieth century. Nearly every newspaper and magazine reference to him or his work includes the phrase "great marine painter," lists him among the two or three most accomplished masters at whatever kind of art the article is discussing, or ranks him alongside Whistler, Sargent, Homer, or the great Dutch and Italian masters of earlier centuries. But slowly, as the artists who knew Woodbury and prized his work so highly faded from the scene, and as

American art itself moved farther away from its nineteenth-century models, Woodbury and his paintings seemed less relevant to those who were defining the history and canon. The Boston Public Library showed a large selection of his works on paper in 1944, the Museum of Fine Arts presented a major memorial retrospective in 1945, and the Boston Athenaeum exhibited an important group of Boston paintings, most from the collection of Elizabeth Ward Perkins, under the title "Charles Woodbury's Boston" in 1952. But in John Wilmerding's *A History of American Marine Painting*, published in 1968, little more than a quarter of a century after Woodbury had been counted America's greatest sea painter after Homer, artists as different and as far from marine specialists as Ralph Blakelock, William Morris Hunt, Maurice Prendergast, John Sloan, George Bellows, Childe Hassam, Marsden Hartley, Charles Sheeler, John Marin, Andrew Wyeth—even Arthur B. Davies and Louis Eilshemius—are discussed with reference to marine painting , but Woodbury's name is not mentioned even once. Similarly, Theodore E. Stebbins Jr's comprehensive and magisterial *American Master Drawings and Watercolors : A History of Works on Paper from the Colonial Times to the Present* (1976), the standard work on the subject, contains no reference to the artist who, a generation before, had been considered the equal of Benson, Hassam, and Sargent. Woodbury was, simply, no longer in vogue. From 1952 until the late 1970s, Woodbury's art was in eclipse.

His gradual return to visibility probably began with an important exhibition by Vose Galleries in 1978. Vose Galleries had sold Woodbury's paintings many years before, during the artist's lifetime, but the exhibition of 1978 presented an especially fine collection of sixty paintings, watercolors, and drawings owned by the artist's family. This successful exhibition and sale brought Woodbury to the fresh attention of a new generation of dealers, private collectors, and museum curators.

Then in 1986, an exhibition at the Museum of Fine Arts, Boston, titled *The Bostonians: Painters of an Elegant Age , 1870-1930*, cataloged by Trevor Fairbrother, included Woodbury as one of the important Boston artists overlooked in the general tendency to equate significant twentieth-century American art with New York modernism.

But by far the most important event in the renewal of interest in Woodbury was the 1988 catalog and exhibition at M.I.T., *Earth, Sea, and Sky*, edited by Joan Loria and Warren A. Seamans. Here, for the first time in more than forty years, a large collection of at least two hundred

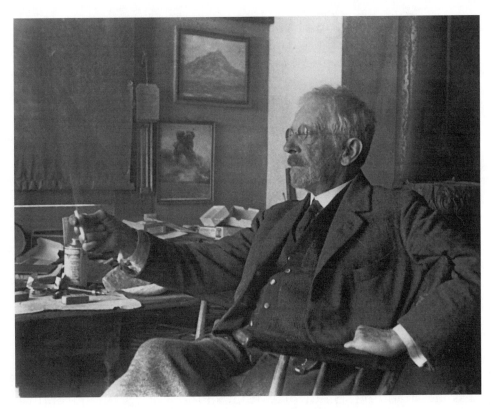

Woodbury at his desk. Collection of Ruth R. Woodbury.

of Woodbury's major and minor works were on display. From M.I.T. the exhibition traveled for several years to fourteen other major museums around the country, allowing a wide general reacquaintance with the work. Since *Earth, Sea, and Sky*, Woodbury's paintings have regularly been included in other survey exhibitions and publications on American art, such as *Awash in Color: Homer, Sargent, and the Great American Watercolor*, edited by Sue Welsh Reed and Carol Troyen, at the Museum of Fine Arts, Boston, in 1993. Reviews of the exhibitions and catalogs have again placed Woodbury's paintings before the public eye. More moderate, perhaps, in their estimation of Woodbury's place in American art than the commentary of fifty and sixty years ago, today's reviews have found in Woodbury's work "freshness and relevance" . . . and "in its optimistic tone, its sense of personal transcendence and concern with painting the data the artist sees, Woodbury's is an essentially American statement, and it is exhilarating."[1] As another put it: "If he painted the same thing over and over again in pretty much the same way, he never became a formulaic painter. His canvas-

canvases are always fresh transcriptions of what he saw and felt. . . .
You may demur today at critic William Howe Downes's ranking of
Woodbury (in 1912) with Homer (and Turner!) as a painter of marine
subjects, but when you look at *Mid-Ocean* (1894), his first major work,
you can understand the excitement it generated."[2]

That Woodbury's reputation is again on the rise may be a reflection
of another shift in public taste, this time away from all the "isms" and
"post-isms" that have made large parts of this century's artistic legacy
perhaps so much more interesting for the academic historian than for
the ordinary lay viewer, and back toward recognizably good painting,
no matter the style or school. Today we can admire the seascapes of
both John Marin and Frederick Judd Waugh, different as they are,
appreciating each for what it is rather than deprecating it for what it is
not. As we move even farther away from partisan judgments based on
which school a particular artist did or did not fit into, Woodbury may
eventually regain his place as one of the two or three best American
painters of the sea—ever.

Even during his lifetime, Woodbury was commended for taking
what he could from the Modernist movement but not falling too much
under its spell. Woodbury achieves a hard-won balance between fresh-
ness and tradition. He displays the boldness of twentieth-century
experimentalism without being trivial, solipsistic, or excessively self-
referential, and the strength of nineteenth-century and earlier tradi-
tionalism without being an old fogey. He was not drawn toward the
emphasis on shock and novelty, the glorification of originality at all
costs, the conviction that to be authentic each successive artistic gener-
ation must overturn the work of the preceding generation, and the
insistence that the best art be beyond the grasp of and diametrically
opposed to the general public taste. Rather than try to keep up with
what was happening in New York or across the cove, Woodbury con-
tinued to paint elemental forces, always moving but not fundamental-
ly changing. Woodbury personalizes nature without distorting it,
emphasizes movement and perception while respecting the integrity
of the object. He augments tradition rather than attempts to overthrow
it. His credo, "force through delicacy and not brutality," allows his
work to remain accessible and engaging long after experiment for the
sake of experimentation has lost its ability to shock.

ENDNOTES

CHAPTER I

1. David O. Woodbury, *Charles H. Woodbury, N.A. Yankee with a Paint Brush* Billerica, MA, 1964, p. 4, originally published in *New England Galaxy*, Vol. V, No. 4, Sturbridge, MA, Spring 1964.
2. F.O. "Yankee." p. 4
3. F.O., "Yankee . . ." p. 5
4. For more about Woodbury's time at M.I.T., see: Warren A. Seamans, "Mechanical Engineering Hath For Him No Charms," in Joan Loria and Warren A. Seamans, *Earth, Sea, and Sky: Charles H. Woodbury, Artist and Teacher, 1864-1940* , Cambridge, MA 1988, pp 4 - 11.
5. *Earth, Sea . . .*, p. 6.
6. "Disreputable Remarks by Charles H. Woodbury," unpublished manuscript compiled by Elizabeth Ward Perkins. Woodbury Papers in the Wiggin Collection. Boston Public Library. Cited by Donald F. Krier, "Paint in Verbs, Not in Nouns," *Earth, Sea . . .* pp. 20 -27.
7. For more information about Green, see Rolf H. Kristiansen and John J. Leahy, "C.E.L. Green," *Rediscovering Some New England Artists, 1875-1900, pp.* 177-179; and Frederic Sharf and John Wright, "C.E.L. Green, Shore and Landscape Painter of Lynn and Newlyn," Essex Institute, 1980.
8. Sinclair Hitchings, "The Graphic Art of Charles H. Woodbury," *Earth, Sea. . . .* p. 43.
9. This and other excerpts quoted or paraphrased from newspaper clippings are from the *Woodbury Black Book,* a large and tremendously valuable scrapbook of papers, catalogs, photographs, news clippings, and memorabilia preserved by the artist's daughter-in-law, Ruth Woodbury. p.2
10. Seamans, *Earth, Sea . . .*, p. 7.
11. Letter to Elizabeth Ward Perkins, April 20, 1915, cited in Roberta Zonghi, "The Woodbury School: The Art of Seeing," *Earth, Sea, . . .* p. 29.
12. Black Book, p. 2
13. Black Book, p.2
14. Black Book, p. 3

CHAPTER II

1. William Howe Downs, "Charles Herbert Woodbury and his Work," *Brush and Pencil*, April, 1900. pp 1-12.
2. Black Book, p. 216

3. Black Book, p. 220
4. David O. Woodbury, "Susy Oakes —The Girl Who Couldn't Paint," *The New England Galaxy, 1966, pp. 3-12.*
5. F.O., "Susy. . . ." p. 6
6. Roberta Zonghi, "The Woodbury School: The Art of Seeing," *Earth, Sea . . .* pp. 29-42.
7. F.O., "Susy . . .," p. 8.
8. F.O., "Susy . . ." pp. 10- 11.
9. D.O. W. , *"Yankee . . ."* ₄ p. 3.

CHAPTER III

1. Black Book, p.9.
2. Black Book, p. 10.
3. Black Book, p. 11.
4. Black Book, p. 11.
5. William Howe Downes, "Charles Herbert Woodbury and His Work," *Brush and Pencil,* April 1900, p. 10.
6. Downes, p. 10.

CHAPTER IV

1. Louise Traggard, Patricia E. Hart, and W.L. Copithorne, *Ogunquit Maine's Art Colony, A Century of Color, 1886-1986,* The Barn Gallery, Ogunquit, 1986, p. 2.
2. Black Book. p. 20
3. Black Book, p. 50.
4. Black Book, p. 58.
5. *Earth,Sea, . . .* p. 25.
6. Cited by Roberta Zonghi, *Earth, Sea . . .,* p. 31.

CHAPTER V

1. *A Century of Color,* p. 37.
2. *A Century of Color,* p. 37.
3. Carol Walker Aten, *Gertrude Fiske, (1878-1961),* catalog, Vose Galleries, Boston, 1987, p.4.
4. Aten, p. 5

CHAPTER 6

1. Birge Harrison, "Recent Tendencies in Marine Painting," *Scribner's Magazine,* vol . XLIV, no. 4, p. 470.
2. Arthur Hoeber, "Charles H. Woodbury, N.A., A Painter of the Sea," *The International Studio,* vol XLII, no. 168, p. LXXII.

3. Black Book, p. 49.
4. Black Book, p. 115.
5. Black Book, p. 17.
6. Black Book, p. 196.

CHAPTER 7

1. For more on both the book and its prototypes, see Marie Donahue's Introduction to the reprint of *Deephaven,* by Sarah Orne Jewett, Illustrated by Charles Woodbury and Marcia Oakes Woodbury, published for the Old Berwick Historical Society by Peter L. Randall Publisher, Portsmouth, NH, 1993. Also: Babette Ann Boleman, "*Deephaven* and the Woodburys," *The Colophon,* August 1939.
2. Black Book, pp. 98, 99
3. *Earth, Sea . . .* p. 49
4. Black Book, p. 145.
5. *Earth, Sea . . .* pp.18,19.

CHAPTER 8

1. John Taylor Arms, "Charles H. Woodbury, Etcher," *Prints,* vol. V, No 1, November 1934, pp. 21-33; Arthur W. Heintzelman, "The Woodbury Exhibit," *The Bostonian,* December 22, 1944, p. 30
2. *Earth, Sea . . . p. 49.*
3. Cited in "Etchings by Charles H. Woodbury," catalog by Frederick Keppel & Co. February 18 to March 14, 1925.
4. Arms, p. 26.
5. Charles H. Woodbury, *Painting and the Personal Equation,* Cambridge, Mass., 1919, p. 91
6. C.H.W., *Painting . . .,* pp. 69-70.
7. C.H.W., *Painting . . .* p. 56.
8. Arms, p. 24
9. Arms. p. 26.
10. Arms, p. 30.
11. Arms, p. 28
12. Arms. p. 26

CHAPTER 9

1. C.H.W., *Painting,* pp. 113-115
2. C.H.W., *Painting,* p. 29.
3. Black Book, p. 9
4. *Earth, Sea.,..* p. 70

5. Black Book. p. 139.
6. *Earth, Sea* . . . p. 83.
7. *Earth, Sea,* . . . p. 86.
8. *Earth, Sea,* . . . p. 101.
9. *Earth, Sea* . . . p. 99.
10. *Earth, Sea* . . . p. 102.

CHAPTER 10

1. Black Book, p. 162.
2. Black Book, p. 25.
3. John Wilmerding, *American Light: The Luminist Movement, 1850-1875, Paintings, Drawings, Photographs,* The National Gallery of Art, Washington, 1980.
4. For Bricher's works, see Jeffrey R. Brown, assisted by Ellen W. Lee, *Alfred Thompson Bricher, 1837-1908,* Indianapolis Museum of Art, 1973. For Richards, see Linda S. Ferber, *William Trost Richards, American Landscape and Marine Painter, 1822-1905,* The Brooklyn Museum, 1973.
5. Black Book, p. 20.
6. For Aivazovskii's life and works, see V.N. Pilipenko, *Aivazovskii,* 1817-1900, in series Khudozhnik R.S.F.S.R., Leningrad, 1983.
7. John Wilmerding, *A History of American Marine Painting,* The Peabody Museum of Salem, Massachusetts, Boston, 1968, p. 222.
8. David O. Woodbury, "Charles H. Woodbury, the Marine Painter Who Was a Graduate Engineer — A Personal Appreciation," catalog, Vose Galleries, 1978.
9. Black Book, p. 11
10. Black Book, p. 81.

CHAPTER 11

1. Black Book, p. 77. Boston Transcript, April 21, 1915.
2. Black Book, p. 77
3. Black Book, p. 93

CHAPTER 12

1. Black Book, p. 153.
2. Black Book, p. 153.
3. C.H.W., *Painting* . . . pp. 92,93.
4. C.H.W., *Painting,* . . . p.94.
5. C.H.W., *Painting* . . . pp. 94,95
6. C.H.W., *Painting* . . . pp. 87,88.
7. C.H.W., *Painting* . . . pp. 32, 33.

8. C.H.W., *Painting* . . . pp. 33, 34.

9. Feb. 8, 1920, in Black Book, p. 278.

10. May, 1920, Black Book, p. 279.

11. March 27, 1920, Black Book, p. 280.

12. E.B., "A Star Map to Paint By," Black Book, p.283.

13. G.W. Harris, "With Brains, Sir! The Psychological Factor in Painting," *The Evening Post*, New York, March 13, 1920, Black Book, p. 282.

14. C.H.W., *Seeing*. . . . p. 10.

15. C.H.W., *Seeing*. . . . p. 12.

CHAPTER 13

1. Robert Taylor, "Woodbury Painted in Verbs, Not Nouns," *The Boston Sunday Globe*, May 22, 1988.

2. David Bonetti, "From Sea to Shining Sea: Charles Woodbury Rules the Waves," *The Boston Phoenix*, July 22, 1988.

ABOUT THE AUTHOR

George M. Young grew up in Madison, Indiana, studied at Duke (B.A., English) and Yale (Ph.D., Slavic Languages and Literatures), taught Russian and comparative literature at Grinnell College and Dartmouth College, and since 1978 has directed Young Fine Arts, Inc., conducting auctions of American and European paintings. Earlier published works include a book and many articles and essays for scholarly journals and anthologies, as well as the entry for the *Cambridge Encyclopedia of Philosophy* on the nineteenth century Russian philosopher N.F. Fedorov. He, his wife and two children live in North Berwick, Maine.